MANTIS FORCE

MARIUM KAHNET

RETRIBUTION

A novel by

R. J. Amezcua

ISBN: 978-0-9980748-2-5 (pbk.)
ISBN: 978-0-9980748-3-2 (Ebk.)

QUENTOREX
STUDIOS

438 E. Shaw Ave #410
Fresno, California 93722

help@quentorexstudios.com

www.mantisforce.com

To

MY WIFE

SHERYL

who not only blessed me with her editing skills,

but also supplied encouragement in abundance

during my journey in the peaks and valleys of

writing my first novel

and to whom

this book

is

Lovingly Dedicated

CONTENTS

Chapter One

RAMAH

Jazrene Vallo trailed behind a group of families as they followed a dirt pathway through the Teenoke forest toward the cemetery. On this last day of Hoshkadish, many mourners were on their way to pay remembrance to the tens of millions slaughtered during the global attack thirty years ago. Feeling a need to be alone for a moment, her steps slowed and she let the distance between them widen. High-pitched chirps from a flock of white birds skimming through the sky caught her attention. Tilting her head back, she watched them through the lacy branches of the towering majestic trees until they disappeared from her sight. Enjoying the clear skies that flooded the forest with light seemed the right thing to do. She, like every Ramah citizen, was obligated to pay homage to the slain within the days allotted, so she soon resumed her journey down the now silent path.

At the edge of the forest, she strolled down a well-worn path heading toward a group of small boulders at the edge of the cemetery. For as far as the eye could see out into the distance were the many resting places of those whose lives had been taken during the attack by Kravjin and Necrogog forces on Planet Ramah, in

their attempt to kill Abba El's Messiah.

Her steps were cushioned by lush green grass, which carpeted the gentle slopes adorned with large swathes of beautiful wildflowers. Drawn to a patch of lavender flowers near a half-buried boulder, she gracefully sat down. Leaning forward, her fingertips brushed the petals of the nearest flower as she breathed in the light scent. "My favorite color." She sighed with pleasure. Her silver eyes were tugged toward the rows of small dirt mounds, the resting places of the infants and little children in the near distance. The stark white headstones were marked with their names and clan affiliations.

Feeling the weight of the moment, she lifted her hand, respectfully pulled back her hood, and began to pray. She watched parents chasing their young children as they darted about, shrieking in joy and dodging the half round headstones. A couple of the little ones tripped over each other in their exuberance and fell. Her soul cupped their pitiful cries, merging them with the deep groaning in her own bosom. *These children's cries seem as though they are my own. Though I have the scars from the many trials and tribulations in my life, my heart is kept tender by Abba El's love.*

She closed her eyes, momentarily savoring the refreshment of the cool breeze that swept through the Valley of Nuak as it brushed against her pale cheek. She had a sense she was being watched and turned her head toward a nearby mound, meeting the stare of a middle-aged woman kneeling next to a headstone. Her swollen red eyes reflected the depth of despair and grief that had not diminished despite the large span of years that had passed. Jazrene had empathy for her pain, as she was deeply familiar with it. One of her main duties in the intervening decades had been to visit families,

to comfort, console, and assist them in moving forward. She wondered if this heartbroken mother was one who had lost more than one child during the global infanticide. The woman's pleading eyes probed into hers as though she would receive an answer to the unspoken questions that were on everyone's heart, especially on this day. Why had this happened and why had Abba El allowed it?

Most Ramah citizens were aware of the prophecy that Abba El's Messiah would come forth by a Marium Kahnet virgin. However, no one could have predicted the rage of the enemy of their souls—Kravanoblus—that had instigated the fruitless attempt to hunt down the Mantis Messiah and kill him, which resulted in the mass murder of nearly a whole generation. Her heart was gripped anew with the unspeakable despair she and the woman shared. Her own children and family members were among those who lay at rest in the very row where the woman was kneeling.

Jazrene Vallo's new life's journey had begun all those years ago on the day of the massacre.

She'd been in the deserts of Jezreal, testing for a leadership position in the Hadassah Clan. Emerging from among the dark caves of the mountain ranges of Theramore, she had seen what she believed were the first twinkling stars of the approaching night. But she quickly realized they weren't stars at all—they were ships in combat, their fire littering the twilight skies high above.

She ran around a tall boulder near a ledge, and in the far distance saw menacing pillars of black smoke that blotted out the proud

cityscape of Moriah, the capital city of Ramah. Fear squeezed her like a serpent in its coils, and she struggled to breathe. She was released from the paralyzing shock by a powerful surge of desperation as the faces of her family flashed in her mind.

With their safety her only concern, she ignored her better judgment and traversed more than sixty kilometers back to her home on foot. Arriving a day later, she found her hometown in ruins. A wave of nausea hit the pit of her stomach as she reached her home and staggered among what remained. The stench of death enveloped her. In horror, she collapsed to the ground near the body of her beloved husband with two of their three children wrapped in his arms.

Jazrene did not know how long she remained there crying for them to come back to her.

Then, the realization hit hard that her daughter Minna Lavine was missing. She rose with an adrenaline surge of strength to search for her—but it was to no avail. Minna was gone.

The pain of losing her entire family was overwhelming, and she had reached out to the Marium Kahnet leadership for comfort in her bereavement. But she soon discovered that most of the leaders had been slaughtered as well. In an effort to squelch her paralyzing grief, she volunteered as a search and rescue team member. But the unrelenting cries of despair and unspeakable grief caused by so much loss, and the countless tiny lifeless bodies that littered the streets took its toll on her soul. The once strong towers of her will crumbled to dust. The foundations on which she had built her life were destroyed; now she was estranged, without hope and direction,

as the beacons of wisdom that once guided her were snuffed out.

Disoriented, she moved amongst the rubble of her life in a catatonic state, eventually making her way deep into the Badi Sered desert some distance from home. Her spirit completely broken, she walked aimlessly day after day among the dry and barren ravines. Occasionally, a breeze carrying the smell of destruction reinforced her state of mind and spirit. Soon Jazrene couldn't remember the last time she'd eaten, and her dry and bleeding split lips cried out for water. She felt the cold shadow of death approaching—and in fact, a pack of Mongolu Raptors had begun stalking her—but she couldn't bring herself to care.

One day as she was staggering among the craggy rocks, beneath the relentless heat of the sun beating down on her water-deprived body, her vision began to blur. Crumpling onto the hard surface, her knees struck sharp rubble, and she let out a meager whimper. She pitched forward, scraping and slicing her once beautiful complexion, completely lacking the strength to break her fall with her hands. She vaguely felt the scorching heat of the jagged rock against her already sun-burnt skin, and moaned in pain. Blood dripped from her nostril to the side of her mouth. The metallic taste caused her stomach to heave, and she tried to spit it out. Hearing the creatures scrabbling in the cliff faces all around her as she lay at the bottom of a wide ravine, she forced her eyes open and waited for them to attack. No doubt the carnivores were excited by the smell of blood, and like a mirror of her life, they were ready to rip her to pieces without mercy. Completely numb, her life began to slip from her.

Then, from the depths of her tortured soul emerged a tiny ball of light, which melded into the single tear that rolled down her cheek.

This last bit of moisture representing the remaining life in her body was now ready to perish on the altar of despair. Barely conscious, she felt a strong sense of peace spring from within. She began to sing the song of hope and faith in Abba El, and the promise of the coming of HIS Messiah in her heart. Her lips parted, but no sound was heard, for the song was in spirit. The single teardrop hit the rock surface and her mouth closed slowly as she felt the spirit of death approach.

Scantly aware of her surroundings, she heard the creatures' warning calls as they scurried away. Her spirit could sense a strange but familiar presence. She gathered what remained of her strength, wearily lifted her head, and squinted at two brilliant lights that appeared in front of her. Immediately, her spirit recognized that they were Malakphos, divine messengers of Abba El spoken of in the oral traditions of the Marium Kahnet and by the prophets of the House of Mantis.

"Peace be with you, Jazrene," one of them said. "Do not be afraid. The promised child, the Messiah, has been taken to the planet Shalem to fulfill that which is written about him in the Kodashah, the holy book of the prophets. Be strong and live, for you are to strengthen your sisters in the difficult days to come. For it is written that the daughters of Chawah and those bonded together in godliness will be among the ordained vessels commissioned with great journeys into the dominions of the enemies of light and truth." The strong voice rolled over and drove through her, echoing mightily off the impervious rock surfaces and down the canyon beyond.

"Yes." Her blistered and bloodied lips parted as she responded with all of her might, expelling with force the air out of her lungs,

causing a small explosion of dust to erupt in front of her face. She struggled momentarily to draw in another breath.

The second Malakphos stepped forward. "You will live and not die, for it is also written that some of the Hatahrim, the sealed ones of Abba El during the Iratus Shaphat, the twenty-one judgments of Abba El, shall be called and chosen from among you." His right hand extended toward her. "Now, consume this blessed Victus gathered from the ledges of this ravine to regain your strength. The divine being placed the substance in her open hand. You have passed through the shadow of death and been found faithful. You are worthy to partake. Take and be strengthened."

As he drew nearer to her, the holy presence imparted some strength to her starved body. "Fear not, Jazrene Vallo, daughter of Abba El, the Most High God. For you have been chosen and ordained for a new journey. You are to refashion, strengthen, and restore the Order of Marium Kahnet." His voice echoed loudly in the wide ravine.

And then, as suddenly as the Malakphos had appeared, they vanished.

Her body ached as she slowly sat up. The renewed grumble of her stomach demanded that she eat. After she examined the green and bluish leafy substance, she put some of it into her mouth and gulped it down. Her face contorted, repelled by its bitter taste. A pool of water that had not been there a moment before appeared in front of her. Without hesitation she crawled on hands and bloody knees toward the gleaming surface. With her face poised just above the water's surface, she felt its coolness as she scooped the crystal

clear liquid into her parched mouth with one hand. The slightly bitter taste of the Victus began to dissipate. She gasped as she suddenly remembered that the plant that was unique to this particular ravine, though full of nutrition, was poisonous to most life forms and most certainly to humans. The thought made her stomach clench, but already vitality was surging through her body.

Pressing her hand to her mouth, she closed her eyes, as she concentrated with her spirit and discerned the poisons in the foliage had been changed somehow. Her spirit recalled the word from the Malakphos. She would not die, but would be strengthened if she ate it. She consumed the rest of the Victus in small bites with tiny sips of water in between.

Did the Malakphos impart the ability to manipulate my cells at the DNA level? she wondered. *Can I impart this knowledge to others?* Her strength rose, along with her vigor, as her cells and molecular structure continued to rapidly respond to the Victus. With renewed energy, she plunged her hands into the pool and splashed the water over her face and scraggly hair. She felt refreshed, examining the plump, youthful looking skin of her hands, and marveled. *It must be the Victus.* Lifting her head, she surveyed the ravine, noting that her vision and her senses were elevated to a much higher degree than before. With eyebrows pleated, she leaned over to peer at her reflection in the crystal clear depths of the pool. Her head jerked back and she gasped in shock, then looked again into the watery mirror. Her once leaf green eyes were now a luminous silver. She stared at her glowing reflection for what seemed an eternity. Her auburn hair had streaks of stark white and her physical appearance was once again youthful.

With the words of the Malakphos replaying in her mind and spirit she stood up, alive with renewed strength and purpose. But the urging of her spirit tugged her back to her knees. Her face lowered to the ground, then her mouth released a groaning from the deepest part of her being. The voice that had been imprisoned behind the bronze gates and iron bars of hopelessness was now free.

She recited Yaqal 6: "The cries of my soul ascend up to Bayit El, for the fountains of joy in the valley have ceased. My eye beholds no beauty. Where is the lovely? I am clothed with calamity. I wearily pass through the land of trials and tribulations. The mirage of a joyful life evaporates as I stand on the burning shores of utter despair. The cold waves of cruelty of the bottomless abyss lap at my feet, and the dark sands of my circumstances mock my life. But I firmly stand on the unmovable foundation of HIS Messiah, for HIS truth parts the sea of darkness and I see the land of HIS promise. Glory to Abba El in the highest, Amen." She could see the crushed iron bars swept away by a mighty hand, and reveled in the fresh freedom and deep peace.

Jazrene's contemplation of her memories that were forever frozen in time was broken by a child's shriek of excitement. She looked to where a tiny girl was running from behind a tree toward the woman who had been fixedly staring at her a moment ago. Jazrene smiled as the child threw herself into the woman's arms. Surreptitiously, the woman wiped her eyes with the back of her hand as she clutched the child's tousled golden-haired head to her bosom. The woman hiccupped and laughed with the joy only a grandchild can give, and

stood, taking the little girl's hand. She glanced back at Jazrene for a moment, and subtly shook her head side to side...no. The message conveyed between the two of them made it clear that she, like many in Ramah and surrounding regions of space, would do everything in her power to deter her daughters from joining the Marium Kahnet.

The sole reason that Ramah had been attacked all those years ago was to eliminate the Messiah who was given, as promised, to a virgin from among the Marium Kahnet.

Jazrene watched them move away and silently blessed the woman and her family. She had been taught at an early age that forgiveness was a mighty weapon, able to cut one loose from the bonds of bitterness, which inevitably leads to illness. Even after the Marumspora, the great scattering of the sisterhood from Ramah, she was able to act in grace, which epitomized the way of the Mantis to her enemies and to those who turned coldly away from the sisterhood out of fear and, sadly, for revenge. Like the gentle breeze that was even now washing over her, she let the spirit of ungodly judgment and resentment be carried away with it.

She sensed individuals approaching from behind and turned to greet them. It was two of the daughters she had adopted as young girls, more than twenty-five years ago after the planet-wide attack. The orphaned Jada Zabella and Sonja Naphti, like so many of the new members during that time, were hastily engrafted and ushered into the Order of the Marium Kahnet. But truth be told, most had been adopted solely for continuing the sisterhood's legacy. This was of course blatant hypocrisy, since it did not reflect true wisdom or the righteousness that were among the many virtues exemplifying the ways of the sisterhood. After achieving the rank of Hadassah,

Mother of Marium Kahnet, she had ordered an immediate adoption moratorium to seek other more reasonable solutions to the problem of their dwindling numbers. She lifted her hand, drawing their attention, and they smiled as they made their way to her.

Bowing their heads out of respect for their mother, they both said, "Greetings, Mother Jazrene." Sonja's melodic low voice was quieter than usual.

"Greetings, my daughters." She nodded and fluidly rose, glancing over her shoulder toward the hundreds of rows of small dirt mounds stretching into the horizon. Jada and Sonja followed her gaze to the field of graves and became reverently still.

"It's time for the conclusion of the Shakaroth." Jazrene's soft voice broke the solemn silence, drawing their attention back to her. She looked deeply into their eyes, discerning their spiritual state, and then nodded encouragingly.

"Yes." Sonja softly cleared her throat and looked away, at another group of families heading in their direction.

Jada gracefully extended her arm, the flowing sleeve of her garment fluttering about her wrist as she gestured to the path near them. "We have a shuttle waiting, Mother." Her smile, as always, was genial and the stirring of Moshiach that had been imparted to her when she received the new covenant between Abba El and man made her face subtly glow.

"We will leave in just a moment," Jazrene said, touching Sonja's forearm, and then turned her attention to the families heading directly toward them. With the Order struggling to shore up flagging public

opinion and the subversive opposition within the government of Ramah, she had availed herself of every opportunity to minister publicly. Her hope was renewed to a small degree to hear the sincere requests for prayer and blessings from among these families as they encircled her and her daughters.

Chapter Two

SHAKAROTH

Jazrene, Jada, and Sonja gazed through the large viewport of the transportation shuttle and observed Abba El's ordained renewal of the cycle of life that occurred every spring. They marveled at the sight of vast herds of long-horned Bantazan grazing the tops of the thick islands of tall Ambanax trees. Jada pointed out, with restrained excitement, two fully-grown Xagu Raptors, fierce predators that were rarely seen in daylight and had no equal in the plains of Shavason.

The transportation shuttle smoothly made a course adjustment over rolling hills, which were carpeted with blossoming flora. The spectacle of the delicate and opulent beauty, a virtual sea of vivid colors, visually announced that spring had arrived on the Slavavaga continent. At the edges of the hills, the reflection of the sun's rays off hundreds of small pools of water sparkled like precious jewels. Jazrene smiled as she watched Jada looking down on the majestic spectacle, and saw in her sparkling eyes how her soul was uplifted and inspired. She couldn't help but be moved herself by the vivid tapestry of the renewal of life on display below.

The shuttle skimmed close to the steep slopes of Mount Gamasham. The bright white fur of the mighty and agile Tibus males stood out against the dark formidable jagged slopes as they pursued potential mates up the treacherous mountainside, where only creatures of flight dared to traverse. Jazrene began to compare the challenges that she faced every day with those of the mating rituals of the Tibus. The slightest slip during their courtship, and their future legacy would be dashed on the perilous slopes.

She watched the nimble mating ritual for as long as she was able as the shuttle swiftly passed by, pondering the parallel of the ordained cycle of life of the Tibus to that of the sisterhood. *I stand with my legacy at the precipice of oblivion and that of the Holy Order of the Marium Kahnet. My enemies offer me bitterness to drink; bread kneaded with offenses and clothing lined with thorns. But the still small voice within me calls out. I am a new creature, renewed with a divine love that cannot be bound with chains, for I am strengthened by the promise of life eternal, which has been given to me because I believe and have faith in Abba El and in HIS son the Redeemer of man and all creation. I pray that while I am tried and tested, that the vapor which is my life be received in Bayit El as a sweet smelling sacrifice.*

She closed her eyes and from the darkness, a spinning ball of fire appeared, and sparks shot in every direction around her as it pressed against her. Immediately it began to burn away small particles of black chaff from around her eyes. In an instant, the purifying blazing sphere lifted away and then vanished. Appearing in its place was a gold key. An inaudible voice urged her to take hold of it.

With curious fascination, she reached out with her spirit man and did as was asked of her, plucking the key from in front of her. As she possessed the glittering object, a white book with gold along its

edges appeared within an arm's length away. Her eyes were drawn to the center of the book where an oblong plate of gold with an opening in the exact shape of the key she held lay empty. "Place the key onto the book," the voice in her spirit instructed. With complete trust, she set the key in its place.

Under its power, the book opened. She recognized at once the brilliant tome as the Kodashah, the Holy book of the Prophets. The pages were semi-transparent and the sacred text emitted wisps of golden mist, which formed Reshmek letters and symbols, of the first language, last spoken many millennia ago. The glowing multi-dimensional words spoke subliminally in Lingue, the divine spiritual language of the redeemed. The voice spoke of the prophets and of Abba El's Messiah, of things that were to shortly transpire and of those that would come after. In a flicker of a moment she was taken into the realm of the indescribable... her true home. The verses on the pages of the divinely inspired book and words spoken testified strongly within her own spirit.

The vision abruptly vanished and she opened her eyes, meeting those of Jada and Sonja. Her spirit felt the longing to return to her true home.

"Mother, we sense a strong presence of Moshiach." Sonja's face glowed as the murmured words left her lips.

Jazrene nodded slightly, encompassed in the strong sensation reverberating through her soul of the soon to come promise of going to her eternal home. Beside her, Jada and Sonja opened their hearts and minds to drink to the full the presence of Moshiach.

After landing at the nearly empty transportation hub, the sisters exited the docked shuttle and made their way to a side entrance in one of the oldest sections of the monastarium complex. They heard the trumpets sound, signifying that the Mantis Prophets had arrived and the ceremony was about to begin. Jazrene treasured in her heart the annual visitation and participation with the prophets of Mantis in the ceremony. They had always supported the sisterhood since their Order was formed.

The Mantis, along with the Prespators, were among the first of the Grand Assembly to earnestly assist them shortly after Kravanoblus cast his shadow over her home planet. In the effort to kill the prophesied Messiah who would call the redeemed from eternal judgment and rule as the only true GOD, the Tisrad Dragon—their enemy's other name—had ordered the forces of Mavet sorcerers and Necrogogs to attack Ramah and slay every child 2 years of age and younger. None had been spared, not even those carried in the womb. In retribution for providing the vessel from which the anointed child was born, the dark forces set out to completely wipe out the sisterhood from existence. This resulted in the great dispersion of the sisterhood, known as the Marumspora.

It had been more than a decade since Jazrene had traveled to Mantacletos, the Mantis Alliance galactic capital world of the Zhanifra galaxy, to participate in the convocation and spiritual bonding ceremony between the sons and daughters of Abba El. That had been a momentous occasion as the Grand Assembly and

the Order of Marium Kahnet established a covenant that the Holy Order of women would soon be fully grafted into the supreme body of the twelve Houses of Kelkemek. The ceremony had also been highlighted by the rare appearance and participation of the Prespators from the Order of Watchers, who headed up the consecration ceremonies. The sisterhood had taken a step closer to their transformational rebirth, and ultimately into their ordained destiny.

In the distance, bluish heavy rain clouds moved toward the nearby Xoronava mountain range. Jazrene and the sisters walked through a small pocket of cold air, shivering; a reminder that winter was still present in the higher elevations of the Parshaun plateau. The ground shifted beneath their feet as they transitioned from the hard metal surface around the main landing zone, sinking slightly into the plush green and blue-carpeted wet lawns. Jazrene led the way, followed closely by Jada and Sonja, onto a mat made partly of machine and partly of fibrous material, which removed excess moisture and soil from their vestments as they approached the entrance. The ornately carved double doors slid into the walls, allowing them entrance into the spacious hallway.

A sense of expectation descended on them as they made their way to the sacred chamber where the Shakaroth ceremony was held every spring. This cherished place, secretly called Kehder, was the birthplace of the Marium Kahnet and where Marium, the blessed one, had been visited by several Malakphos who ordained her to establish the sisterhood. The divine messengers imparted to her the words of truth and the prophetic promise that from her bloodline, a virgin would give birth to Meshua, Abba El's Christ.

23

Jazrene felt almost weightless as she proceeded toward the center of the chamber, while Jada and Sonja stopped several meters inside, as was required of the two witnesses by the customary edict. As she approached the half-buried pentagon-shaped Mevaseret stone, she nodded in acknowledgment to those already gathered there.

Seated along the chamber walls, four meters above the gleaming white stone floor, were prominent citizens, government officials, and the Prime Minister of Ramah, Nephera Tam Samgasat. A group of Mantis prophets sat in a separate section opposite the main entrance. Jazrene felt pity for the Prime Minister, who had walked away from the sisterhood in her youth after the massacre thirty years ago, blaming the Order for the tragedy. She had attributed her mother's early death to the grief and pain from the loss of her infant twin sons as well as her husband, and used it as her platform to get elected to her current post. Jazrene had been made aware from confidants within the higher offices of the Ramah government that the Prime Minister wished to prosecute the sisterhood for war crimes. But, since the convocation between the Marium Kahnet and the Grand Assembly had already taken place, the sisterhood wielded a considerable amount of influence. In addition to that, rumors of individuals being resurrected by members of the sisterhood on Ragoon Three were spreading like wildfire across Ramah. So for now, any attempt to move forward with her schemes to legally persecute them were on hold, indefinitely. The Prime Minister's only consolation was watching the sisterhood's inability to add sufficient numbers to sustain the Order.

A few meters away from the monolith, Jazrene bowed in acknowledgement of the two prophets who stood on the other side

of the Mevaseret stone. High above in the center of the dome-shaped ceiling, a ten-meter section retracted into the walls. Sun rays flooded through the oculus, announcing the commencement of the final day of the Shakaroth. It was customary on the fifth day of the ceremony that two prophets from House Mantis would interpret the visions. This year, it was Arjon Gunga and Tefo Asrat. Jazrene lifted her hands up to Bayit El and blessed the name of the most High.

She fell still as she watched an invisible door slide open within the oculus. A shimmering golden cloud of fine mist made of translucent particles visible to all gently drifted down. Some of the brightly sparkling dew landed on her and continued to fall until it formed a thin, semi-transparent covering and surrounded the Mevaseret stone. She gracefully stepped through the glittering veil until she was completely enveloped by the divine mist, glistening like a precious jewel lit by the sunrays, stunning to behold. The shimmering curtain was drawn upward and gathered to form a wide golden ring that hovered above the Mevaseret stone.

She placed her hands over her heart. "This is what I see. A crescent moon rising over five great seals. Each seal displays a crimson red crest of the royalty of darkness. The first seal is that of House Krauvanok, but the others are a mystery. They are supported by the horns of a dragon, and are given the rod of Necronos and the Rod of Empires. They give birth to a multitude of small horns." Her voice trailed off as the vision ended.

Jazrene waited for the next vision to be revealed, if one was to come. A wave of almost blinding energy burst from the golden ring. "This is what I see. A thick dark cloud has transformed into two

large featherless black wings. They are unfolding, revealing a large and powerful dragon with armored scales standing on two large legs. On its forehead are five distinct symbols. It has four arms with long sharp talons on the tips of its fingers. Three of its arms are fully extended forward, and in the center of each of those clawed hands are several beings. In one of the dragon's hands is a group of Surapharin; in the second hand are the five rulers of the realms of Creminmorta; and in the third are Mavet sorcerers. Tendrils of intense dark energy arc from the beings within the three clawed hands to the fourth hand positioned in the center. The fourth hand is now encapsulated in a sphere of blue and red plasma." A moment lapsed before she continued to speak, "I see inside of that sphere. There are five glowing dragon eggs that are hovering above a pentagon shaped stone. Each egg has a distinct color: green, red, gold, blue, and purple." The second vision faded away, and she waited for a time for another vision to come, but none appeared.

Everyone in attendance watched the shimmering gold ring transform back to its previous form, the swirling mist of transparent gold dust making its way upward through the oculus, and vanishing into from whence it came. The chamber's atmosphere was filled with wonder. All eyes and ears were now fixed on the two prophets.

Tefo Asrat stepped forward, and briefly looked upward through the oculus before speaking. His deep voice was clearly heard throughout the chamber. "Mother Vallo, this is the interpretation of your first vision. The crescent moon rising represents things to come. Of the five seals, one represents the Krauvanok, while the others are unrecognizable because they have not been established. The horns represent the power of the Tisrad Dragon, which will

form these five kingdoms into one authoritative body. He will then bestow upon them the rod of Necronos to have authority and dominion over the Necrogog races. They will also be given the rod of Empires, which will firmly establish their kingdoms. The multitudes of small horns are their many children, some of which will become powerful empires in the age to come. As it is written in the Kodashah:

"Apocapha 16 ζ 6

"From the realm of Augranash will emerge a fierce beast, its five heads each sealed with the dragon crest. Above it, a woman clothed in scarlet sitting on a crescent moon, drinking a cup full of the blood of the innocent.

"And also,

"Apocapha 16 ζ 7

The multitude of small horns on the back and tail of the five headed beast will wage war against the children of the light."

Asrat bowed his head and returned to his position. Gunga waited a moment, then moved fluidly to where his peer had previously stood and met the eyes of the Kahnet Mother. "Here is the interpretation of the second vision. The dragon is the lord of darkness and the five symbols on its forehead represent Spirradeus, the five spirits of the Tisrad Dragon." He paused to let the revelation settle in the hearer's minds. "The energized sphere you saw represents a convergence of realms to create a new powerful race of beings. This new force will be created by combining resources from the Surapharin, the five rulers of Creminmorta, and the Mavet sorcerers. The eggs mean

27

that they have yet to be birthed, while their colors mean that they each will be birthed in the five galaxies of the Quintástraya. As written in the Iratus Shaphat of the Kodashah, specifically in the book of Mamlakah 13 ζ 7:

"Behold, I see many mighty and frightful beasts from the depths of the dark abyss, which spew torment out of their mouths and have power in their tails to cause untold destruction. The number of them is two hundred billion, and it has been given to them to wage war against the five clusters of stars for their allotted time.

"And also,

"Mamlakah 13 ζ 2

Birthed from the essence of abysmal darkness are raging beasts of fierce brutality; they wear the crown of death, and are given the scepter of unmitigated cruelty. They overcome many."

Jazrene felt as if he was looking right through her. The assembly was absolutely silent as they watched Gunga move solemnly back to stand next to Asrat. Jazrene lifted her hands and worshiped Abba El and uttered musically sounding Lingue. From where they stood, Gunga and Tefo interpreted the utterance into Reshmek, the common language. This led all to stand and give thanks to Abba El, marking the end of the ceremony. The chamber quickly filled with excited conversation. Jazrene remained near the stone, waiting for the two prophets to reach her.

"Mother Jazrene, may we have a word with you before we depart?" Gunga's tone was gentle but firm. "The elders of the Order of Yashar have a message for you."

Jazrene's humble nature made her unaware that most in the Order of the prophets had great respect for her and the sisterhood. Her entire focus was solely on the task given to her by the messengers of Abba El of the refashioning the Marium Kahnet. "Yes, of course, my lords." She smiled with pleasure and inadvertently caught the glare of Prime Minister Samgasat, who was approaching the group of prophets discussing the recent ceremony. Jazrene immediately looked away in disgust.

She noticed Master Tefo take a quick glance in the Prime Minister's direction before turning back to her. "This life is temporal and fades like a mist of water in the heat of the midday sun." Asrat glanced toward Gunga, who had already begun to intercede for her in the spirit. They stretched their hands palms outward toward her.

Asrat took in a measured breath. "So I say to you Mother Vallo, we break off your shoulders the yoke of bitterness in the name of Meshua." After the pronouncement, their hands returned to their sides. In the spirit, the two prophets saw a small thin black cape lined with thorns that had just landed on Jazrene vanish. Her face brimmed with a joyful smile.

"Thank you for blessing me. Please come with me to the main gardens," she said, and gestured to the exit where Jada and Sonja stood waiting.

The spacious garden was filled with a myriad of blooming flowers that enveloped them in a plethora of colors and rich scents. The rain-soaked ground had dried in the warmth of the day, and they

began to relax after the intensity of the ceremony. Jazrene led the group deeper along the flowerbeds to the edge of the garden. "The visions were disturbing, in light of their interpretations." She spoke contemplatively as she gazed upon the lovely petals of Rosmadreme flowers. She turned to face the prophets with a solemn look on her face.

Gunga met her silver eyes. "Agreed, very troubling. The Grand Assembly will not be pleased with our report." He glanced at Jada and Sonja, who seemed to consume his every word as if it were food.

"Yes," she agreed quietly. "Let's get business out of the way, shall we?" She pointed out sections of the sprawling monastarium complex that still lay in ruins from the Kravjin and Necrogog attack from thirty years ago.

"Has the Grand Assembly not sent an adequate amount of building materials and supplies?" Asrat asked as he assessed the conditions of the structures. Jazrene was sure he already knew the answer, but wanted to hear it directly from her.

She understood that the Mantis Alliance's main focus was to win the war against the forces of Kravanoblus across the five galaxies of the Quintástraya. Because of that and her edict not allowing the other four Hadassahs to send any assistance, the reconstruction efforts were stifled. She recently had begun accepting help from other sources, some of whom were of questionable character. Just ahead, a flock of Lunanova birds with beautiful blue and green luminescent tipped feathers landed near the orchard of fruit trees at the edge of the garden.

"I am very grateful for the Yashar's longstanding support," she replied. "The Grand Assembly has been very generous over the years and has sent more than an adequate supply of materials. As you may or not be aware, most of our resources have been diverted to the refugee camps on one of our moons, Ragoon Three. The expanding war has displaced many families in the neighboring systems. I understand that further assistance may not be forthcoming for the foreseeable future, but I stand firm in my commitment to look after the wellbeing of the refugees." She glanced upward to the beautiful amber moon, an oasis of hope and a beacon of safety.

"We do not question the integrity of your motives or decisions regarding this matter, Mother Vallo, for it is even as we had foreseen it." Jazrene followed Gunga's intent gaze to a small reptile camouflaged amongst tall stems of flowers, stalking its prey. "You are, however, correct in your assessment of not receiving further assistance at this time. Especially now, given the revelations of five new powers that are at this very moment being formed. The Grand Assembly will most assuredly shift their focus and allocate every resource to seek out and destroy that emerging threat. And that will include a large buildup of forces of the Mantis Alliance outpost on Ragoon Two." Gunga referred to Ramah's second moon, as he surveyed the foliage for the little predator.

Continuing their stroll, they entered a small clearing artfully arranged with seven colorful and ornately crafted stone seats. "Please." Jazrene gestured for everyone to sit.

"Now, about the matter we wish to discuss with you. It has come to the attention of the Yashar elders that several individuals have been brought back from the dead on the lunar colony. Is that true?"

Asrat stared deeply into Jazrene's silver eyes.

Jazrene was not taken by surprise that the prophets knew of these signs and wonders. "Yes, it's true. There were two instances where this happened. The first event was nine months ago. I personally investigated and interviewed the families of the seven individuals who were brought back to life after having been deceased for two days. Apparently, following their deaths, members of each family who did not know one another were instructed in dreams to bring the bodies to Benji, a small lunar colony on Ragoon Three. They were specifically told to ask for a group of Marium Kahnet sisters, who were fasting and praying in preparation for the Barayalad, the completion of the Order's rebirth."

"This is highly unusual." A light frown touched Gunga's brow. "It happened much more when Meshua walked amongst us. Who are these sisters?"

"They are sisters Wen, Kalani, Janan, and Adah. Each has journeyed from their respective galaxy to take part in the Barayalad event."

"We have read the Orders new bylaws and tenets that you sent to our elders and to the Grand Assembly. We are supportive in the direction the Marium Kahnet is headed." Asrat paused momentarily for emphasis. "This may be a confirmation for you. The individuals' resurrections are a sign of your Order's rebirth."

"We are blessed to have your support." Jazrene's voice broke with emotion momentarily. She swallowed the lump in her throat and continued, "Yes, it testifies in my spirit that our rebirth is near." Her face, still glowing from the earlier ceremony, lit up even further, if it

were possible. "The four sisters stated it was during the first watch, when they were visited by messengers of Abba El. They were given instructions to resurrect the dead that day. So they waited expectantly and in the early afternoon, the families arrived at the entrance of the cave. The witnesses said that the faces of the sisters were glowing brightly and they felt a strange sensation of peace. Without a word to them, the families opened the coffins and moved to the side of their loved ones. The sisters walked between the lifeless bodies and held their hands over the foreheads of the deceased individuals. At each person, in succession, they said, 'Lakum Zoe,' which means, 'get up and live.' Moments later, they all rose from their slumber." Jazrene watched closely, waiting for the prophet's response.

"Praise Abba El! It's true. That is a definite sign and wonder!" Gunga's eyes closed for a moment, reveling in the miracle. "How long ago did that take place... have they repeated it since?" His voice rose in excitement.

"No, it was that one instance two months ago," Jazrene replied, unable to hide the disappointment in her voice.

"Are the sisters still on Ragoon Three?" Asrat's tone reflected his concern for the sisters.

"No. They have been moved here, Master Asrat. They are preparing to undergo the ceremony of Victus Konia, the trial of life. If they are successful, they will be elevated to the office of Abess. If they are not, they will remain here after the Barayalad for further evaluation."

Her gaze swept toward a group of sisters approaching, bearing silver trays full of refined Victus bread, void of toxins, and cups of

clear water taken from the very same pool she had drunk from in the ravine long ago. She made sure that everyone was served first before she received her share, as was their custom. "Let us partake of communion." Jazrene tilted her head up toward the sky. "We give thanks in Meshua's name." She consumed her portion, and the others followed her lead.

As often occurs during the course of family gathering, levity took hold and laughter filled the garden. Soon the sun's rays were blocked by a single cloud, as if signifying the end of their fellowship. Asrat and Gunga stood.

"It is time for our departure," Gunga said with a joyous smile. Jazrene and her daughters also stood.

"Be blessed, sisters, and may Moshiach continue to guide your path. You finished well, Mother Vallo," said Asrat with a solemn significance in his tone.

Jazrene bowed her head, receiving the words. "May you continue on the path laid before you, Masters Asrat and Gunga."

The two prophets bowed and headed back to their ship. Jazrene sat back down and watched as they were escorted by a half a dozen Alamah Canonesses, unmarried virgin disciples, back to their waiting ship. It deeply pleased her to see Jada and Sonja enjoy the moment. She savored the rare pleasure of joy and laughter. It did not happen often at the monastarium. For a fleeting moment, she pondered on the prophet's words, *I finished well.*

In the distance, the movement of several sisters working amongst a row of fruit trees caught her attention. She recalled the days of

her youth when the gardens and orchards had been tended by hundreds. Now, less than five dozen worked the vast grounds of the monastarium; its cavernous halls, once filled with melodies of praise, now lay silent.

"Greetings, Mother Vallo, sisters Jada and Sonja," said a familiar voice that broke her muse. She greeted Sisters Raziz Asranath, and Melah WuDaz, elders from the clans of Sharath, with a genial smile as they bowed their heads in respect to her as their spiritual leader.

"We hope we are not too early," Sister Raziz said excitedly. Jazrene admired Melah's large green eyes, and thick red hair adorned with a stylized tiara headband.

"Not at all. Please sit." As they sat, they took a moment to enjoy the kaleidoscope of brightly colored rosebloom butterflies, fluttering just over their heads.

Jazrene addressed Jada and Sonja. "Would you please excuse yourselves for now?" Her firm tone made it clear that it was not a request.

"Yes, Mother, of course," Sonja answered straightway. They both stood and respectfully acknowledged the two elders, and left.

"Well, I have some good news!" Raziz's face beamed with joy. "My daughter Sarah has decided to allow her youngest daughter, Anika, to join the sisterhood at the appointed time for new disciples." Melah also had a wide smile.

Jazrene eyes lit up with excitement. She leaned toward Raziz, took hold of her hand, and gently squeezed it. "That's wonderful to hear, Raziz," she replied, genuinely pleased to hear the news. "I am sure

you must be so proud. I am so happy for you and your family."

Their smiles gradually faded, as a very dire matter needed to be discussed.

"Now then, I believe you have something for me?" Jazrene's stoic demeanor hid her feelings.

"Yes, we do, Mother Vallo." Raziz's firm tone was softened by her beautiful face. She placed a palm-sized metallic disc in Jazrene's outstretched hand.

How many wayward sisters have we found this time? she pondered as the device scanned and verified her DNA and instantly activated. She silently read the data displayed on its surface:

Location:	Augatar region
Birth name:	Alias:
Mila Geodora	Balese Thanas
Zara Adendro	Fay Sinadendra
Asandra Oxomul	Mirinda Kuffa
Loreen Lesedi	Nia Xongol
Tamray Dresovan	Orisa Sotasen
Dilia Tarsus	Taona Xongol
Vivika Nefrisunni	Victoria Maja

As she had done many times over the decades. Jazrene burned

into her memory this new list of individuals who'd left thirty years ago, seeking to exact revenge on the Mavet sorcerers. "The Augatar region, hmm… where is that located?"

"It's near the Tartarus star clusters just inside the Rakia Expanse," Melah explained.

"Why am I not surprised." Her tone remained emotionless, but inside frustration boiled. "The last few wayward sisters we found were located within the five dead zones of the Quintástraya. Are these sisters living like some of the others in peace, or are they planning to cause harm?" She could only hope as she peered into Raziz's sapphire eyes.

"Well, we are not sure. But we do know for certain they are deeply involved in a highly secretive project, which is heavily defended." Raziz sounded equally disappointed with the spotty intelligence they had about the project.

Jazrene stared at the names once more and deactivated the device. She continued to firmly hold the device with both hands, waiting patiently for the instruction she knew would come.

And then she heard it—the still, small voice which had guided most of her life spoke to her once more. *"Bring them back to Ramah,"* it commanded.

"Yes, I will do as you ask of me, LORD," she said in her spirit.

With eyes still shut, she stayed in the moment. In an instant, her spirit was whisked across time and space, arriving at the shores of the prophets. She stood at the edge of the water and saw arising from the sea a sequence of mighty beasts warring against each other.

Near the shore just above the waters, a golden crown appeared. She trembled at the sight.

"Do not be afraid, but be at peace," the omniscient voice said. "This is the crown of victory, which you will receive." The voice was so powerful it shook her spirit.

Just then, two Malakphos appeared very near her. She sensed that they were the very same ones that saved her life in the ravine thirty years before. "Jazrene Vallo, you will soon leave your temporal tabernacle. Fear not, you have faithfully finished the course set before you," said one of the divine messengers.

With that, her spirit leapt back to the garden. Melah and Raziz gazed at her inquisitively.

"We sensed the spiritual atmosphere change. Would you care to share what you have seen or heard?" asked Melah. Raziz's eyes pleaded the same.

She peered into Melah's eyes and then Raziz's "I have seen the victor's crown," she said triumphantly. The two looked at each other, puzzled, and then back to her. Calmly she explained, "What that means is that I am being called home shortly." At their shocked gasps, she continued with a genial smile, "I am not afraid. I do not know the circumstances. But it is for certain that I will leave this temporal temple very soon."

She remembered the device and gave it back to Raziz. There was silence for a moment.

"Let us continue with the matter at hand." They nodded in agreement, bewilderment in their eyes. "We must secure the

appropriate assistance. These sisters must be returned back to Ramah at all costs. So I, Jazrene Vallo, eldest mother of the order of Marium Kahnet, authorize Lakad." Her silver eyes glistened with wisdom and her brush with eternity.

"We have heard and witnessed your authorization to capture the rogue elements of the sisterhood, as a top priority," the two affirmed in unison. The weighty moment hung in the air, as this was authorization to bring them back dead or alive—an order Jazrene did not give lightly.

"I will see you to at the Barayalad. Now I must attend to other matters." Jazrene's hands stretched toward them as they rose to leave, and they held hands momentarily. "Be blessed, and use wisdom in choosing the proper assistance. Guard my confidence in you both about my coming departure."

"Yes, Mother," Raziz replied for them both. They gracefully bowed, then made their way out of the gardens, leaving her once again in silence.

The distinct ceremonial horns of Kahnet sounded in the distance, announcing the time had arrived for the Konia Victus ceremony. She hoped the four sisters would pass the test and receive their new spiritual mantle of authority to be elevated to the office of Abbess. She surveyed the beauty of the garden as she strode upon the moist grass.

In the spirit, she examined herself and saw the number of cracks widen in the pillars of her steadfastness, caused by the weight of the monumental task of reorganizing the Order of the Marium Kahnet over the years. The reformation was difficult at best even with the

support of the Grand Assembly. Exacerbating the difficulty was the unrelenting strain of family clans vying for more influence in the Order's rebirth. But she knew that in the very near future, the proper order of things for the sisterhood would manifest according to Abba El's perfect will and timing.

She glanced at the moons. "Hmm, so the wayward sisters are near the Tartarus star clusters. What are those sisters up to, and why are they so important that a divine messenger instructed me to bring them back to Ramah, dead or alive? No matter, they will be home soon, and so will I."

Chapter Three

LETALIS

High above in an observation tower, Taona Xongol stood close to the protective shielding of a transparent metal viewport, surveying the vast area of land developed specifically for live combat, which made up the Stadageo. This battleground was located just inside the Rakia Expanse, on the Planet Letalis.

Her nostrils flared as memories of the tragedy that befell her more than three decades ago pricked at her heart. Her soul groaned deeply and she squeezed her eyes shut for a moment, bracing against the pain. *I have not forgotten you*, she told the flitting images of her family members who had been massacred, that turned to ashes. "I will avenge you... Momma... Daddy," she whispered in a childlike manner, pushing back tears.

Her journey of revenge had begun when she joined other Marium Kahnet sisters who left Ramah to follow the trail of the Krauvanok priests responsible for the attack on their home planet. But, as they reached the planet Gahenna, just inside the Rakia Expanse, they'd discovered the priests' involvement in strange bio-engineering

projects. The sisters set aside their plans of immediate assassination of the murderers for the time being in favor of destroying the projects. Using false identities, the sisters used their vast knowledge of bio-sciences and volunteered at several local medical facilities. Years later, their quality of work garnered the interest of the all-seeing eyes of the Stadageo Science Authority (SSA). They were all unceremoniously transferred to the Stadageo projects and initially given the task of analyzing the data on unusually constructed stasis pods. Over time they had gleaned that the pods were actually mechanical wombs, which were used to contain newly created hybrid warriors of ungodly melding. The pods were transported to the planets Letalis and Necropis, deep within the Rakia Expanse.

It was at this juncture that the sisters came into agreement to anonymously contact the Mantis Alliance and alert them of the projects. Not long after the message was sent, the Mantis Alliance military came in full force. They effortlessly broke through the defenses of Gahenna and completely destroyed every complex involved in the Stadageo project. The sisters surreptitiously made their way to one of the main security complexes to verify and gloat in its destruction. Moved by compassion at the pain of the people, they helped the injured as much as they were able and moved on to another area where most of the bodies had been completely vaporized. It was then they realized that they could assume the identities of those casualties and travel to Letalis or Necropis and replicate the destruction.

Now, fifteen years after Gahenna, here I am. Ready to strike another blow to my enemies with my sisters. Taona's spirit was troubled, and she closed her eyes to pray. But as usual, it seemed as though her prayers were

blocked by an unseen force. Her mind fought against a multitude of voices laced with contempt and condemnation. *You know that those with hearts darkened by vengeance will not be heard in the courts of Bayit El.* A derisive voice condemned her repeatedly with the words, "You are a murderer." Her conscience testified to that truth that had been ingrained into her as a youthful disciple of the Marium Kahnet.

She stared at the horizon, not focused on anything specifically, completely immersed in her internal pain. She began to meditate on the text of the sacred lamentations superimposed over the vivid images of her many loved ones, and that kept her focused on retribution.

Kodashah: Yaqal 7

Darkness is upon Ramah and there is a great lament in the city streets of tranquility. For peace has been taken captive and laughter has been vanquished. Joy has turned into mourning. For her young are cut off from the living and the cries of their innocent blood ascend to Bayit El, as it flows into the dust of the ground. Marium's soul is pulled into the abyss of anguish. Terror fills her heart and her spirit is held within the bronze gates of Sheol. The maw of cruelty and death has caused HIS handmaidens and chaste daughters to scatter among the stars.

"Selah." Her lips parted slightly and the surface of the viewport glazed with the moisture of her breath at the whisper of the word.

Suddenly, her heart blazed with hatred and murderous rage as the faces of her family and those of the sisterhood flitted in her mind's eye. So vivid were the images that resurfaced in her mind that for a moment she actually thought that she could speak with them. But then, like the life she'd previously known, the images vanished

without a trace.

A flurry of ice flakes quickly covered the battleground far below her, as the first winter storm blew into the northern regions of Asbadran. Her eyes followed the path of a single flake as it drifted and landed on the tip of a deadly mobile weapons platform used in the life and death combat trials. She took note that the numbers of combatants had dramatically dwindled since the beginning of the year. She had received secret messages that the same had been observed at the Stadageo on the planet of Necropis.

Hearing a group of individuals in animated conversation, Taona turned and spotted Nia Xongol with the rest of the diagnostic bio-engineer specialists, emerging from one of the transpods near the edge of the wide viewport several hundred meters away. Passing nearby were a handful of the mysterious race of beings of unknown origin. Most referred to them as Tisrak. Pale skin, piercing silver eyes, standing more than two meters tall, with hooded dark robes that covered their heads. They were somewhat unnerving. She was always amazed at their ability to solve and create the highly complex multidimensional blending technology, just like the Kelkemek forefathers during the age of Kelkabara, when creation was in a state of perfection. It was forbidden to address them without being spoken to first. Taona wildly speculated that they were the Surapharin—minions of the Tisrad Dragon.

Just the thought of that made her skin crawl. *What do they do with the victors in the Stadageo combat trials?* She felt a check in her spirit, just then, to think about something else, and she quickly suppressed her curiosity about them. She and her fellow rogue sister Nia had pondered the same question for years.

Glancing at the waves of ice shards pelting the viewport, she joined the teams heading to a waiting shuttle that would take them to their stations underground.

In the belly of the Stadageo, Nia caught Taona's eye, in acknowledgement of the greatly reduced number of transportation platforms carrying two-meter long caskets, which held the lifeless remains of Krauvkar elite commandos of the Krauvanok military. This signified to all that the project had reached its objective. The minds of the Krauvkar now resided in the powerful bodies of hybrid warriors. This unholy melding was accomplished by using the Tridents of Hades, which gave the possessors the abilities to carry out their unbridled machinations. Nia and Taona continued with their groups deeper in the heart of the Stadageo.

Entering the Necronos complexes, where the transfer of the minds and battle experience of victorious Krauvkar elite commandos into the hybrid bodies occurred, Nia and Taona grew even more anxious as they passed hundreds of heavily armored Tartarus military guards. They were the forward guard of the Krauvanok Alliance Overseers coming to officially authorize the ramp down of the project that had created the hybrid Thraku and Garatark warriors. As tight as security was, bits of information slowly spread that the two warrior races created on Necropis had been taken to a region of space near Tartarus. No one knew what their purpose was to be.

The two sisters wondered why these new soldiers had not been deployed against the Mantis Alliance. It was almost as if these fierce

new warriors did not exist, for after reaching their destination, they simply disappeared. No matter; the two now waited for word from their Marium Kahnet sisters, Victoria Maja and Balese Geodora, who had been reassigned to Tartarus by the Overseers under the guise of assisting in a medical emergency five years ago. The Overseers were the governing power over the entire project. The last time they had received word from Balese and Victoria had been more than a year ago and even then very little had been shared about their work, other than they were now members of the Synogog and worked directly for the Overseers on Tartarus. Divulging any information about their project was extremely dangerous for all of them. The risk was attested to by the public executions of those attempting to profit from selling or sharing Stadageo information that happened from time to time. Only general conversations about the public spectacle of the Stadageo combat trials seemed to be permitted.

Strategically, Taona and Nia had married into the predominant clan with ties to the most influential criminal organization in the Letalis region of space. This gave them access to the Muak'Xod spy network, but more importantly, a way to escape off world after they took down the Stadageo. The moment to join the nefarious network was close at hand, with the understanding that this necessary allegiance would bring another set of challenges, as those who were initiated into the Muak'Xod organization were grafted in for life.

Their noses twitched at the acrid humid atmosphere as they made their way down a dimly lit flight of wide stairs. Standing with other bio-engineers, they marveled in wonder at the gray and black oval stones partially buried in the floor, stretching far into the horizon. Taona's flesh prickled as she sensed a strong ugly spiritual presence

approaching. *Tisrak*, she thought, and turned, looking upward to the pale-skinned being. His silver eyes pierced coldly through those around him.

"You have been reassigned to the Necronos fusion flux duties." His sibilant tone wrapped around them with a power that bent wills. A large amulet on his vestment began to glow with various hues of green. Taona's spirit tensed to repel the insidious tendrils of darkness emanating from him, seeking to lodge in her flesh.

"Here is the new Nostrohelix: a formulation to blend and bind elements of this dimension with those of the realms of Creminmorta." He stretched his left hand out and waved his right hand over it. Out of thin air, a dark red, thick metal device appeared in his left hand. Gasps of awe escaped those around them as they were enraptured by the power the Tisrak displayed. Tendrils of white-hot energy laced out from his right hand and engulfed the device. Thick smoke smelling of death curled and spiraled upward. His deep baritone voice loudly chanted, "Talmak ~Shelu ~Nagranu." The authority and power of the necromantic language transcended this realm. The device glowed brightly with energy in the Tisrak's large hand.

"Activate your Nostrodata devices." His menacing voice pricked their very souls.

After quickly doing as they were commanded, he waved his hand over the devices held in their outstretched hands. Taona could feel his dark power trying to enter through her flesh, and she knew Nia could feel it too.

"Your assigned Necronos Pod section is shown on the bottom of

your screen, as are your team assignments. You are dismissed." With that he turned, heading toward another group of bio-engineers a few hundred meters away.

Nia and Taona glanced at a stone partially embedded in the center of their Nostrodata devices. The dark stones were marked with Toxrokk letters and symbols around the edges, and in the center of the stones were three dots. The women were fortunate this time around that they'd been teamed up with Meka Audramoss, a longtime acquaintance. Meka was impulsive and talked big as if to make up for her diminutive stature, but was relatively harmless.

"Looks like this is the end of the Leviathan project!" Meka smiled widely as she approached them, and took a big breath, squaring her shoulders. "Let's hope the next assignment begins right away. You know what I always say...Idle hands rot the mind," she said in a singsong voice.

"You mean idle hands bring poverty," Nia rebutted with her brow cocked.

Meka shrugged her shoulders, turned, and walked away. "Our NPs are located ten rows farther down from here," she shouted over her shoulder, briskly leading the away.

"Well then, I suppose we will just follow your lead, Meka." Nia's sarcastic tone was not lost on Meka, already a dozen meters ahead of them. A snort of laughter drifted back toward them.

Taona glanced sharply at Nia as they followed, and said quietly, "She is young." Nia shrugged her shoulders, but her face softened with a smile in agreement.

They both gave a lot of latitude to the immature bio-engineer prodigy who had been given special access to all research and development sections of the Stadageo, including the extremely restricted area of the Necronos power core stations. Meka had bragged to them about how she had participated in more than twenty Nostrohelix procedures. This was far more than both of them combined. It was unclear at first why Meka had gravitated toward both of them since their introduction, but they had slowly cultivated a relationship with this highly favored person. Over time, this had allowed them to glean a rich storehouse of Stadageo secrets from the somewhat impetuous and headstrong young woman. Meka had eventually confided to them that Nia reminded her of her mother.

The sisters gracefully but with some haste made their way down the center of the pods. As always, they marveled at the technology used to achieve the almost impossible. These NPs were slightly different from the ones they had studied before on Ramah that in ages past had been used to transform the allies and conscripted legions of Krauvanok soldiers known as Necrogogs. These were a lot thicker at the partially exposed base. Two and a half meters from the bottom were a series of wide dark blue metal bands. The top band had a receptacle where the device was to be placed. The lower bands had alien markings and symbols glowing in amber. Their distinctive semi-transparent domed tops flickered continuously, emitting tendrils of red and blue energy. From their vantage point, they could see one of the main energy conduits that powered their section. It also pulsated with blue and red energy. Though the main power core was sealed, everyone was aware that it still released minute amounts of Cremindraux radiation; a death sentence if one got too close.

"It's about time you old ladies made it." Meka smiled mischievously at them, her eyes sparkling with laughter. "Maybe taking Cymbratar is not enough to maintain your strength." She laughed, continuing her light-hearted levity.

"Thirty years from now, your steps will also slow regardless of how much Cymbratar you take," Taona retorted in the same vein. She smiled graciously, then strolled over to her first NP to Meka's left. She placed her Nostrodata device into the square receptacle in the top metal band.

Immediately fine thread-like metal fibers connected themselves into the surrounding NP surface. Surges of red and blue energy coursed through the wires. Even with protective clothing, Taona felt the cold, dark, merciless energy swirling around her and slid her hands into her protective vestment in vague revulsion.

Nia glanced in every direction to see if anyone was nearby as she moved to the NP to Meka's right. Taona could still sense her irritation at Meka's brashness, but she knew underneath that annoyance, Nia had grown very fond of her. At times, when the young lady smiled gleefully, she reminded Nia of her younger sister Celine.

Numerous times during the course of their friendship, Taona and Nia had rebuffed the young prodigy's inappropriate remarks and had reminded her to be careful not to share information regarding the Stadageo project with anyone else. Over time, Meka had divulged just enough information for them to mentally reconstruct the primary infrastructure that supplied power to the necronos transformation pods. With the seeds of vengeance sown in their hearts long ago, and nourished by their consumption of Cymbratar,

a substance imbued with the essence of darkness, they plotted the destruction. The ripe fruit of revenge was now ready to be served.

As agreed, they would wait for the signal from Balese and Victoria.

Chapter Four

RAMP DOWN

Just beyond the Tartarus star clusters, aboard one of the Krauvanok Alliance military ships, Balese and Victoria were ready to proceed with their plans to destroy the core laboratories within the Leviathan project. They would set in motion a coordinated, carefully timed strike in concert with their sisters on Letalis and Necropis against their targets, the Stadageos.

After eating a small portion of food in the dining area, Victoria made her way through the sparsely decorated greeting room that reflected her minimalist mindset and way of life. The past few years living among those whose main goal was to live with unrestrained opulence had vexed her soul. She entered the office of her temporary accommodations in living quarters normally reserved for military high command. The lights automatically brightened, revealing a very utilitarian room containing a commonplace workstation and large dark gray chair in the corner. This room gave her a strange sense of familiarity, as if she had arrived back home on Ramah, in her hometown of Bethel. Victoria sank into the cushioned chair and felt the food that she had just eaten begin to settle. She was aware

that the offices, as well as the rest of her quarters, were likely to have listening devices; they helped her stay alert, ensuring that she kept her thoughts to herself. But she had enjoyed the experience of working long hours alongside Balese on the Leviathan project. It was a far cry from her idyllic life back home, which seemed a very distant memory.

With her arms placed on the overstuffed armrests, she focused on the large signet ring that had been given to her by a Krauvanok Alliance Overseer on Tartarus. Lifting her arm, she gazed intently at the gaudy bauble that signified her Nazar covenant of secrecy. She shifted uncomfortably in the chair and tried to shut out the disturbing thoughts that rose in her mind. The dark metal band around her finger stood out in stark contrast to her slender, light olive-toned fingers. She touched her wrist, trying to remember where the thin band of gold and black metal had vanished beneath her skin and fused with her bone and DNA. This allowed her access to high security areas within the Mecropex, where the final stages of the Leviathan project were held. Except for Balese, a few others with her had chosen the larger band of shimmering gold and black metal that had been placed on the crown of their heads. Disturbingly enough, the frightful and powerful entities being developed in the deepest reaches of the Rakia Expanse were also given similar types of bands.

These fierce new Leviathan races were the root cause of her many dreadful dreams and sleepless nights.

Am I a mother of these spawned unholy beings fathered by the Tisrad Dragon? Will the images of them vanish along with my guilt? She had asked herself these questions many times over the years. Laying aside

the Kravjin meditation techniques she had been taught to subdue growing anxiety and fears, she reached deep into the recesses of her heart. *I see in the distance a glimmer of light.* Her soul began to savor its rays of warmth, but she was rebuffed as she tried to embrace it.

Then, as if she was given new sight, the seemingly impenetrable walls of judgments, guilt, shame, and condemnation rose against her. Letting out a sigh of hopelessness, she accepted her sentence to remain captive within the iron bars of despair until her last breath.

Suddenly, as if someone was standing right beside her, she heard a strong voice say, "You will overcome and live." The voice repeated the proclamation once more.

Somewhat startled, Victoria looked around the room but saw no one. *I must be losing my mind.* But something was already coming to life inside of her. The wonderful sensation of an invisible weight lifting off her shoulders. She relaxed into the feeling, imagining herself in another place and time just a few days after she had completed the Konia Matanot. The room became cavernous and filled with the sights and scents of the lush gardens of the old monastarium. In her mind's eye she saw her younger self in an advanced Kohyim class with her arms and body moving gracefully. "Moshiach is my center. I am under the wings of Abba El," she whispered, completing one motion then fluidly moving into the next segment of the routine.

In the moment of peace, she recalled that she had been given blessings and prophetic utterances by a Mantis prophet and several Marium Kahnet elders. *What were the words spoken over me exactly? Who knows, most likely something to do with a blessed life's journey of some kind.* She breathed deeply. *I have to admit, I've been on a journey. But what*

happened to the blessings? In her head she laughed, mocking herself.

Still deep in meditation, she breathed steadily and relished the sweet aroma of the memories of her beloved family who had perished so long ago. But the vivid imagery triggered a torrent of emotions that suddenly burst through her dam of serenity. It took all the force of her will to hold back her feelings; they threatened to shatter the flimsy façade of a cold, treacherous-hearted woman. Traits commonly associated with those involved in the Leviathan project, especially members of the Synogog.

Gasping, she choked back the overwhelming grief, but the rising anger evaporated the tears in her eyes. With new resolve, she rehearsed every aspect of the plans to sabotage and obliterate the Leviathan project.

The challenge she and Balese now faced was how to notify the Mantis Alliance of their location within the vast void of the Rakia Expanse, more particularly the Mecropex complex cloaked in a massive dark-matter energy cloud. The odds were stacked against their success and escaping with their lives now seemed impossible. The means by which they planned to decimate the Leviathan races would create a multi-spacial phenomenon, an event that had never before been seen or realized within this realm—the harsh realization of which had shaken her to her core. The far-reaching and potentially devastating effect of the multi-dimensional energies, mixed with dark-matter and other forces, was incalculable and frightening in scope. It could very well mean an unavoidable sacrifice of their lives for the greater good.

Now, the time to strike had finally arrived. This was the

culmination of events which had begun fifteen years ago, shortly after she and the two other Marium Kahnet sisters arrived on Letalis and witnessed the life and death struggle of the Stadageo combat trials. Their schemes had grown in severity and risk until she and Balese were transferred to the planet Tartarus, the very doorstep to the heart of the enemy's secret Leviathan project.

Her musings were broken by flashing bright red pentagon-shaped buttons near the entrance of the office. The ship was very close to their first destination, the Stadageo on Letalis.

"All security detail assigned to the Synogog, report to the cargo bay immediately." The loud male voice echoed in the room. Victoria cringed and her lip curled at the mention of the name. Standing up, she adjusted her Nazar cloak, anticipating the next announcement.

"All Synogog personnel report to the quarantine room on Level 4."

Victoria left the office and made her way along the corridor, walking near three-and-a-half-meter rectangular viewports. Mid-stride, she peered out into nearby space and observed two dozen Tartarus warrior class military transports, part of the ramp down convoy. She abruptly turned and headed toward a row of transpods several meters away. Not breaking stride, she entered an open transpod. "Level four." The doors slid closed behind her as she spoke. A moment later, a monotone voice announced her arrival. As she exited, a platoon of military guards entering an adjacent transpod caught her attention.

With purposeful steps, she walked along the corridor wall and nearly collided with Avisha Khanon, who had seemingly appeared

out of nowhere.

"That was close. Hey, are you ready?" Avisha asked politely, with a slightly provoking edge to her tone.

"As always, Avisha," she replied firmly, and continued on her way accompanied by Avisha.

The two Synogog members were joined by others as they neared their destination. "I believe this will be our last trip to Letalis and Necropis. Sadly, there will be no more Stadageo combat trials," Avisha said. Her remorseful tone was not contrived, as her obsession with the bloody battles was well known. Her delight in death matches had somewhat of a voyeuristic element, like she was living through the experiences of those on the fields. "I wonder what will become of the Stadageo?" Avisha's earnest tone reflected her mixed emotions.

Victoria expertly masked her distaste at the topic of conversation. "I believe the Letalis and Necropis governments will most likely use the grounds for their own military purposes, don't you think? That was, after all, their agreement with the Krauvanok Alliance High Command. This is common knowledge, Avisha, and of course they have publicly announced that they have recently joined the Varkrato League."

"I believe that would be a wise thing to do." Avisha's grin looked more like a grimace, a mere baring of the teeth rather than the expression of true satisfaction.

"I wonder if I will be sent back to Necropis or remain here on Letalis," Victoria said earnestly, seeking to guide the conversation in another direction.

"I don't know. But I am sure we can find out if we want to." Avisha cocked her head to the side and looked at her, mischievously. "There are benefits to being the favorite niece of an Overseer who happens to be a high ranking Kravjin member, after all," she drawled, smiling slyly.

Victoria was cautious as always, considering what was at stake. "That might be true, but I think it is best not to pry into things we are not privy to." She glanced at the young woman solemnly.

"I suppose you might be right." Avisha lifted her chin, rebuffing the council of the older and wiser Synogog member.

Twenty-four Krauvkar elite commandoes passed on the other side of the wide corridor. Their helmet face shielding reflected the overhead lighting and their heavily booted feet made a noisy accompaniment to the general clanking of their body armor and hand-held weaponry. The uncanny similarities of combat skills between them and their Mantis Alliance military special force commando counterparts were not lost on Victoria, whose duties included the study of every elite fighting force of the Mantis Alliance.

Victoria glanced toward Avisha, whose eyes were filled with admiration. "They have served their purpose nobly and have sacrificed their lives for the greater good, and for victory over our enemies." Her face took on a haughty look and her chin rose pride fully. "For that, their families will be and are greatly rewarded." Her sanctimonious tone was grating.

"They are honorable warriors indeed." The corners of Victoria's lips lifted briefly in a bare semblance of a smile acknowledging the

statement. It was difficult to reconcile the brutality of this side of Avisha's nature with her other more warm and caring side, which she had exhibited on many occasions.

They entered the access way that led to the compartmentalized cargo bay on Level 4. Upon arriving in the quarantine area, they slid the hoods of their outer garment off and prepared themselves to receive their vaccinations. Victoria, obeying the social norm within the Synogog, nodded toward certain acquaintances with which she had cultivated a sort of friendship on Tartarus. She also subtly greeted sister Balese Thanas, who was receiving the first of the two-part inoculation procedure. A small nod with an inquiringly raised eyebrow was Balese's only reaction.

Having administered an untold number of inoculations, the Synogog medical technicians moved with choreographed precision. Victoria received the first of the two elements. She placed the thin white wafer on her tongue and extended her left arm. A cold tube-like device was placed on her wrist, which activated the transfer of the catalyst necessary for proper vaccination that enabled them to work in the hazardous Necronos complexes. The mild pinch was more tolerable than the irritation in her throat and the nasty taste that lingered in her mouth from the wafer. She quickly popped the green gel tab she was given into her mouth to remove the bitter chalky taste. The soothing effect as it dissolved on her tongue was immediate. She noted the childish complaints of Avisha next to her as she received her vaccination. Avisha stomped her foot and whined, "Can't we figure out another way to do this?"

Victoria chuckled inwardly at the bloodthirsty leanings of Avisha, which apparently did not extend to her own body.

When she was finished, Victoria shunned routines as best she could and chose a new location to stand on the disembarkation platform until the ship landed. Krauvkar warriors stood near the place where she customarily stood before, so she passed by them and paused at a small viewport to observe their approach. A handful of other Synogog bio-engineers stood too close to her liking. Dismissing her irritation, Victoria gazed blankly through the viewport; her mind created a holographic screen, which displayed their detailed plans to destroy the Leviathan project. She knew that the other sisters' plans were also well thought out and as detailed as their own. Over the span of two years, the sisters on Letalis and Necropis had ingeniously sent encrypted messages to her and Balese using scrap and refuse transportation cargo ships, which on occasion traveled to the planet Tartarus. Using this unorthodox method, Victoria had been able to convey the ramp down plans of the projects on Letalis and Necropis to her sisters several months ago.

As agreed by all, she and Balese would strike first, since they had direct access to the Leviathan project and were part of the ramp down process. Then at a precise time, Nia, Taona, Fay, Orisa, and Mirinda would make their move to destroy their targets. Only their plans of escape were kept secret from each other, in case of capture.

Her ponderings took a darker turn as she contemplated what the enemy had accomplished with their assistance. The hybrid warrior races of Drackuvox, Garatark, Rephtak, and Thraku were taken to the Mecropex and imbued with dark energy directly from the realms of Creminmorta, creating the races of Leviathans. These new Leviathans were temporarily held in the black wombs of dark-matter clouds deep within the farthest reaches of the Rakia Expanse. She

and Balese agreed with the other sisters' assumptions that the ramp down of the Stadageo projects meant that the powerful Leviathan races could be released at any time. Even now, they feared that they might be too late to stop it, but intended to go forward with the plans to strike a devastating blow. In an attempt to spare the other sisters the heavy burden of culpability of participation in the creation of these dreadful beings, they'd deliberately withheld the true scope of the Leviathan project from them. The simultaneous execution of their plans was primarily based on the time it would take Victoria and Balese to reach Letalis, then Necropis, and finally return to Tartarus. Victoria and Balese would secretly be given instructions regarding when to strike their respective targets.

A disturbance in her spirit caught her attention. The face of Avisha Khanon surfaced in her subconscious; a warning that as the niece of Gandu Khanon, a Krauvanok Alliance Overseer could be a spy for her uncle or at the very least repeat what she and Balese had been discussing lately. Mulling it over in her mind, she relaxed marginally as she recalled that the only open discussions they ever had in front of her were harmless speculations of the origins of the different sentient beings in these sectors of space—except that of the Tisrak, about whom even Avisha avoided speculating about.

A cloud of multicolored spacial plasma erupted around the ship as it came out of the displacement wave corridor to orbit above Letalis. In the distance, several other bursts of color announced the arrival of the other ships. In short order, the rest of the military transport ships carrying Synogog bio-engineers and other team members appeared nearby. She gazed down at the planet where the land mass was half covered by white and blue clouds. Immediately,

the dozen ships darted in descent through the upper atmosphere. They sliced through the dense black clouds at the heart of the blizzard, emerging from the blinding white flurry over the majestic snowcapped mountainous and craggy terrain. After a slight course correction, they slowed as they neared the vast Stadageo region.

Victoria's lips parted in a mild grin, as this glimpse of the touch of winter, her favorite season of the year, brought her a fleeting moment of joy. *This will be the last time that Balese and I will be inspecting the Stadageos of Letalis and Necropis.* The inner still voice spoke in her mind and heart. *Let the hidden seals of my destiny now be broken asunder, for my spirit is ready to break forth from the bronze gates of my circumstances, to call forth and release the reaper's blade. For the time of the harvest of my life is at hand. I see the shadows of fear fade away as the brightness of my hope eternal rises, and of Abba El and HIS Messiah.* The outpouring of her spirit readied her for whatever would come.

Sensing a presence approaching from behind, she calmed any visible expression and turned.

Suval Bantak, an associate of the Qwravasha High Priests of Tartarus, rudely forgoing customary greetings, spoke while looking over her head. "It's too bad we won't be able to meet with Gandu Khanon when he arrives sometime today." His condescending and boisterous tone grated on her. She stiffened a bit and waited for him to look at her.

As if bestowing her with the gift of his attention, he finally slid his eyes to hers. She ignored his disdainful stare and otherwise disheveled appearance. A number of years ago, he among others had made strong overtures to her. A few were inappropriate. Some

of the men had even proposed to her. She had repelled all of their advances, insisting that her priority in life was her work in the Leviathan project, and that nothing else mattered to her. Which was certainly true to a degree.

"Yes, you are right, it is a shame that we won't be able to meet with Overseer Khanon," she replied. "We will be well on our way to Necropis by the time he arrives." Victoria's disrespect and distrust of him was thinly veiled. He stared into her eyes, searching for a glimmer of hope to continue his attempts at courtship. "As I always say, my life is my work and my work is life." Her lips barely parted as she spoke.

As stoically as possible, Suval Bantak dismissed her rebuff, nodded his head, and shuffled away.

Victoria marveled at the unique battleground super structures of the Stadageos. For the last time, she took in its awe-inspiring complexity. *Soon this will be severely damaged.* Her determination hardened with the coming reality.

The ships landed on the platform next to a tall and thickly built tower. She felt the intent gaze of Balese, but dared not reciprocate, instead taking her cue to follow the others between their military escorts down the ramp. She shivered as they left the warmth of the ship. Ahead was a highly restricted entrance to the Stadageo Necronos complexes, and then down into the belly of the beast. Victoria's lungs filled with the biting cold winter air and she felt as if death himself was announcing that he would shortly come for her. She was comforted in the knowledge that she would soon see her loved ones again.

Yaqal 15

Death comes like a winged beast, which rides upon the whirlwinds of darkness. His fanged teeth are stained with the residue of life; his cold merciless talons pierce my heart. With unbridled fury, he snatches me away and lays me upon the stone altar of fallen creation. But my body is redeemed and my soul is reborn. I am released from the prison of decay and death. I see the SON of HIS promise. Selah.

Chapter Five

OVERSEER

Gandu Khanon strode by two sentries standing guard at the Sanctavocus, a room specially created by sorcerers aided by the information found in the Book of Knowledge. The unique room was used to communicate securely with individuals well beyond the capacity and reach of even that used by the Mantis Alliance. As a member of the Krauvanok Alliance Overseers, he was very aware of his high status and importance.

He adjusted his dark hooded cloak and glanced toward the glowing two-meter tall tanzanite obelisks placed there by Master Gragloc, a high-ranking leader in the realms of Creminmorta. The thirteen multi-dimensional crystalline devices were strategically placed, with precision, set in a semi-circle. A few meters away was a black pentagon platform supported by three thick evenly spaced reptilian fingers with talons protruding up through the thick obsidian tabletop. As he approached the platform, the talons began to glow and discharge blue and red tendrils of energy, arcing to the tanzanite obelisks. The obelisks pulsated with energy and released bursts of highly charged multicolored energy into the surrounding walls made

of materials taken from the mines of Daugravog.

The atmosphere plummeted to near freezing. He could see the moisture of his breath crystallize, forming small clouds of white mist in front of his chin. The multi-dimensional properties of the chamber walls created a muffled sound as the warp field around the four walls charged the air. The high ceiling turned into liquid silver, and three individuals clothed in the vestments of the Kravjin high council emerged from behind the thresholds of the prismatic crystalline-like veils.

The blended corporeal and spiritual essence of them made their way to Khanon. After they greeted each other, they moved to stand on either side of him. Knowing what would occur next, they looked fixedly at the writhing energy within the three claws. A large, dense black cloud of mist descended from the shimmering silver pool above and hovered over the black pentagon platform. Chi Ku Ren, the Kravjin Supreme leader of the high councils, emerged from the midst of the sulfurous clouds.

Immediately, the four of them bowed in reverence and respect.

"Greetings." The old Kravjin sorcerer raised his hands over their heads as if to give them a blessing.

"Welcome, Master Ren." The subalterns bowed their heads slightly, keeping their eyes riveted to his.

"As you all are aware, we have reached the end of the projects on Letalis and Necropis. The end of the testing is at hand. Within five days, we will deploy our new Necronos elite fighting forces of Leviathans. We will deal the Mantis Alliance a crushing blow and

wipe them out of existence." His somewhat thin, reedy voice was filled with the utmost confidence.

"Master, are we to expect continued supplies and resources to fortify our military bases in the Fortuu Expanses?" Narak Angad's question hung in the air for a brief moment. Angad was the high priest in charge of the distribution of resources and materials to the secret military bases in the largely unexplored regions of space in the Fortuu Expanses.

"Yes, of course," Ren immediately continued. "Now, I have been advised by Kravanoblus himself that we should focus on increasing our presence in the Vlberium galaxy." His gaze turned to Durgo Gandahari, the Qwravasha representative of the Praxvarna galaxy, then to the great Rishna Atharva, the high priestess and representative of the Kilodromus galaxy.

She was the only female on the high council of Qwravasha whose understanding of the Book of Knowledge surpassed all except for those in the Kravjin council. Rishna had ascended to the highest ranks of the Order of Qwravasha after she made safe passage through the depths of the abyss of Barracura, in the realms of Creminmorta. As evidence she had accomplished such a journey, she exhibited the supernatural powers of a Qwravasha high priest to the elders.

"There will be a temporary suspension on those supplies until the release of the Leviathan forces. After that, we will continue to build our presence in the Kilodromus and Praxvarna galaxies," Ren continued before turning his gaze to Gandu Khanon.

"Gandu Khanon, I have been informed by our intelligence

agents, who are very reliable…" He paused for a moment, glaring knowingly into Khanon's eyes. "There are infiltrators within the Stadageo projects on Letalis and Necropis. They are reported to be our mortal enemies."

Khanon gasped in shock, his countenance turning ghastly pale, as the implications sunk in. If such reports were true, his very life could be forfeit. He opened his mouth to speak, but was immediately silenced as Ren raised his hand, palm out, indicating that he was not finished speaking.

"Spare me the excuses, Khanon. Some among the council, myself included, have decided that your life will be spared since you have been instrumental in developing the Leviathan project. After all, you were the only one chosen to travel to a Varmagad and return with a Traghedrin key, which allowed you to accomplish the impossible. However, there is a condition to this commutation. You must find these infiltrators and execute them immediately."

He exhaled, feeling the joy of life once more. "Yes, master, as you command." Khanon's weak knees strengthened, and he sucked in a relieved breath. The coldness of the death sentence moved away from him.

But a moment later, dread descended upon him and the three priests beside him, and they collectively shrank in fear. A solid black film slid over Ren's eyes and his face became still and vacant looking, shifting into a trance-like state. His hands shot into the air and turned bright, glowing red. Tendrils of energy arced from his palms to the liquid silver surface of the ceiling. Instinctively, they took several large strides backward in self-preservation. The energized

silver began to fall in large elongated drops, striking the black floor surface between them and the Kravjin Master, who stretched his hands outward.

"Almus~Challum~Gotha~Thallon," he said in a loud voice. Plumes of thin black smoke expelled from his mouth as he repeated the command.

Unknowingly, the sorcerers had continued to creep backwards at the spectacle unfolding in front of them, creating a more comfortable distance between them and the energized pool of silver. From the midst of large ripples in the center of the pool, a large black reptilian tail emerged. It undulated and transformed into a bi-pedal dragon wearing Creminmorta necronos battle armor. Glowing on its reptilian head was the symbol of Navmolek, god of religion. Its partially covered arms revealed power pulsating between its scales. On its armored chest was a crest identical to the one engraved on their Nazar rings. One of its fearsome faces glared at Master Ren, the second at the awestruck sorcerers.

"I am Lord Abbadon, guardian and enforcer of the Nazar Covenant." Its voice was piercing and powerful; the words carried a physical and spiritual force that buffeted them and easily penetrated through their vestments and ceremonial cloaks. They immediately bowed low in obeisance and paid homage.

"Greetings, Lord Abbadon." Gandu Khanon had never seen a Spectrarex and felt like he could stare at it forever. The high-ranking Watcher from the realms of the Tisrad Dragon was a fierce and powerful being that resembled to some degree the new races of Leviathans.

"I have come to walk among your kind. I will command and execute those that I will. None will be spared." The timeless beast pointed one of its sharp talons over them. The smell of sulfur and smoke rose from the poison dripping from its tip. "Gandu Khanon, I am bestowing a great honor upon you. From now until your last breath, I will guide you when I see fit and you will not fail to obey my commands." The Spectrarex bared its blade-like teeth.

The hapless sorcerer trembled, understanding that any failure on his part would most likely mean a swift and very painful death. He struggled to remain upright, internally cringing with terror. "Yes, Lord Abbadon, I am very honored that you will guide me." His voice shook.

The mighty beast lifted a clawed hand over its head. "Memso Alshak." The loud alien command created a strange red and black spherical vortex above its head.

"Chi Ku Ren, prepare yourself, for we will arrive shortly to the place appointed," said the beast's second head.

The Supreme leader bowed in respect. "I am honored, my Lord and Master." Ren spoke respectfully, seeming to have returned to his normal state.

The relief was palpable in the room as the mighty beast released a fiery breath and abruptly vanished into the swirling vortex. Khanon, realizing that he hadn't been breathing normally for quite some time, shook off the residue of the encounter and quickly composed himself.

The Kravjin Supreme leader's voice bit into the silence of the

moment. "Look here!" He stared at Khanon and then the others. "Until our next gathering, prosper in knowledge and wisdom of the Tisrad Dragon." The pronouncement seemed more a threat than a blessing. He turned and was engulfed once more in a black cloud that immediately dissipated after he left.

"Until the next meeting then, Gandu Khanon," said his three peers, who then turned toward each other, dismissing themselves with a nod and disappearing into the multiphasic walls of the chamber.

With his heightened spiritual discernment, Khanon searched for the presence of the Spectrarex, but to his relief he was alone. Swallowing hard, he dismissed the dread of having a personal audience with Abbadon. He adjusted his vestments and straightened his Nazar ring. *I wonder how much time has passed*, he thought as he made his way out of the Sanctavocus chamber. The lapse in time due to the phenomenon caused by the connections between the various dimensions was at times great. Khanon exited the Sanctavocus with purposeful strides to inspect the containment modules once more.

Commander Atta, the ship's senior communications officer, quickly approached the Overseer before he entered a transpod. "Lord Khanon." The commander waited to be addressed.

"What time will we arrive, Commander?" he asked somewhat distractedly, all the while thinking of the Hedropex spheres, which were actually the Orbs of Power taken from the Tree of Sheol, housed in the belly of his ship.

"We will exit the Displacement Wave Corridor in .05 hours." Commander Atta, fundamentally a very pragmatic person, got right

to the point. "The latest reports from the Synogog teams indicate that they have successfully powered down the dark-matter power matrix cores of the necronos complexes of the Stadageo on Letalis and Necropis. It will now be possible to remove the Hedropex spheres. As ordered by you, only three of your six ships will descend to Letalis. The others will remain in orbit." The confidence in his voice reflected the knowledge that the Overseer trusted him.

"Very good." The warm timbre of Khanon's voice conveyed his satisfaction. The report was exactly what he expected to hear. "Commander Atta, notify the other two ships to re-inspect the multiphase containment modules, and ready them for immediate activation." The order reflected the paranoia of failure that might cost him his life. The visitation with the Spectrarex would now never be far from his mind.

"Yes, my lord, as you wish." The commander's tone was strong with resolve. He nodded respectfully to the Overseer and left his presence to fulfill his new orders.

The ships he was using weren't optimal, but Khanon was familiar with making due with less. With his innate resourcefulness and information contained within the Book of Knowledge, he had successfully retrofitted 6 five-thousand-meter long Krauvanok Chevka class battle cruisers to transfer the Hedropex spheres, which emitted high levels of Cremindraux radiation. Using newly developed energy-masking field technology, his ships were virtually invisible.

Lowering the hood of his cloak, he entered a transpod and spoke decisively. "Level three."

After finishing the inspection of the containment modules, Khanon made his way to the disembarkation level, and strode confidently toward several ranks of Tisradeen soldiers assigned to guard the perimeter of the ship once it landed. The sound of large metal clamps securing the ship reverberated through the thick hull. A series of wide, large metal doors slid open with a hiss of pressurized air escaping. With weapons at the ready, the Tisradeen immediately streamed down the ramps.

Khanon stood at the ramp's edge and focused on the other two ships landing atop their respective platforms on the impressive vast grounds of the Qwravasha temple. The platforms, including the one he was on, began to descend under the temple grounds. The bite of cold was replaced with warmer air from a series of conduits, which transferred the enormous dark-matter multiphasic energy of the Hedropex spheres to the Necronos complexes of the Stadageo. The modulating flux regulators had been shut down, making the removal of the Hedropex spheres a less dangerous task.

He, unlike most of his peers, had many relatives on Letalis and Necropis, as well as a strong family presence on Tartarus as a result of the blood covenant between his forefathers and Navmolek. Peering into the enormous underground complex of the temple, he observed the busy activity of the new Qwravasha converts scurrying around a massive field of obelisks near what appeared to be a new type of Necronos pods being installed. *I wonder why Kravanoblus has ordered us to install these cloning and transformation Necronos pods under all*

of the new temples and not use them as part of the Leviathan project. Setting aside the musings, he made his way down the ramp as the massive platform completed its journey to the bottom. Moving with large strides, he noted the Tisradeen expanding the defense perimeter to completely surround the ship.

The Qwravasha high priest of Letalis, Master Dargo Sanwolf, and the council members of the temple were waiting patiently for him nearby. They saluted him with the traditional lifted arms with one fist cupping the other. "Mullgoth!" The greeting of the lower ranking acolytes made him proud, and he heartily responded in kind.

"This way, Lord Khanon." Sanwolf gestured toward a waiting shuttlecraft several meters away. Once aboard, it swiftly carried them to the central control complex where they would observe the removal of the Hedropex Spheres in relative safety. In light of infiltrators amongst the work force, as indicated by the Spectrarex, extra security measures had been put in place.

Khanon glanced back to his ship, where a large containment module constructed with grade three Kelkatanium, one of the hardest composite materials in the known universe, was being unloaded. The highly sophisticated containers were needed to dampen the dark-matter multi-phasic energy emitted from the Hedropex spheres, and high levels of Cremindraux radiation. The containment modules carried within each ship had taken as much resources and time to complete as the entire project had, just as he had anticipated. He beamed with the pride of his achievement.

The shuttle reached the central control tower abuzz with activity. Khanon followed Sanwolf into the tall structure and straightaway

entered a transpod. "Level one." Sanwolf's raspy voice revealed his high level of stress. Gandu Khanon understood the heavy burden of his responsibilities but offered no words of consolation. The doors slid open and the entourage swiftly headed down one of the wide hallways toward the observation center.

From within the safety of the reinforced building, Khanon, Sanwolf, and the others observed the removal of the Hedropex spheres from one of the workstations near the transparent blast shielding. With all eyes riveted to the energized globes, the sudden temperature drop in the room pierced their intense concentration, sparking mild complaints. Khanon also noticed the change and sensed a familiar presence pass behind him. He turned but found no one, only whispers that echoed about the room. Furtively, he looked at the others, but no one else seemed to have heard them. He remained silent and watchful, while the others were now openly complaining about the near freezing temperature in the room.

Sanwolf, frowning, spoke loudly, "Ambient temperature level eighteen."

All of them anxiously waited for the room temperature to warm, but it did not. Fear slid up and down Khanon's spine and others gasped, as a large smoke-like shadow appeared in the center of the room. Deep inside Khanon's spirit, he knew that it was the iniquitous Spectrarex, Abbadon, appearing to them.

Sanwolf, a coward at heart, was inching toward the emergency escape doorway behind them. It was clear that he intended to leave

his brothers to whatever would come their way. But, the irresistible urge to see a real omniscient being from the kingdoms of the Tisrad Dragon overtook his better judgment and he stopped.

The misty black cloud transformed into a single solid form. Abbadon's massive frame and the surges of energy emanating from his body enhanced his already fierce appearance. This time, Khanon noticed the Spectrarex had two wing-like appendages on his back as he turned to face the cowering priests among the group, who were now making their way to the main door.

"Stop." The power of its voice gripped them. They halted in fear as the beast took in a large breath. Trembling, they turned and sank to their knees, bowing to the floor in reverence, worshipping the beast. "I am your Lord and Master. Serve me or die where you are."

After the last of their devoted utterances trailed off, the Spectrarex released a sibilant hiss, accompanied by a grimace that bared razor sharp teeth. He pointed a sharp talon at the priests and with a flick of his reptilian hand, commanded them to rise and leave. With heads still bowed and knees weak, they unsteadily made their way out of the room. Abbadon turned his attention to the remaining Qwravasha priests. "Rise, my loyal subjects."

The voice seemed to penetrate Khanon's heart, and both he and Sanwolf were strengthened somehow by an unseen power. Looking up, they gracefully rose.

Khanon sensed the shadow of fear wash over Sanwolf that tried to overtake him as well. With the force of his own will, he repelled it with some success. Shored up slightly by this small victory, he addressed the mighty being, "How can we serve you, Master?"

The darkly glowing eyes looked deeply down into the two priests' as he spoke. Khanon couldn't help but notice flitting images of unidentifiable creatures outlined in the black wisps of vaporous smoke surrounding the Spectrarex's head. The creatures' red and yellowish eyes and fang-like teeth were exposed as they spoke into the ears of Abbadon. The strange apparitions whispered in an unrecognizable language that slithered into Khanon and Sanwolf's ears, causing shivers to slide up and down their spines.

These hideous creatures are unmistakably Nossorads, Scribes of the kingdoms of the Tisrad Dragon, Khanon recalled from the writings in the Eronash, a tome used by the Kravjin Order. His attention, along with Sanwolf's, remained riveted on the Spectrarex, which was listening to the creatures that suddenly vanished. Small vein-like lines of dark red energy formed across its face, and its gnarled hands balled into a tight fist. The Spectrarex was now completely enveloped in a blue and red energy sphere. Khanon guessed the malefic being had not received good news.

The beast threw his head back and released a deep bellow of violent and fierce anger. The force of it threatened to blast the two of them into the walls behind them. The wave penetrated their bodies like a barrage of invisible fiery darts, causing searing pain. Their eyes watered, and they struggled not to cough as the thick stench of sulfur filled their noses.

"You will do whatever it takes to crush a new religion based on the false rumors of the resurrected so-called Messiah on the planet Shalem." Lord Abbadon's voice bulleted into them. "I want the immediate termination of the family and relatives of this false Messiah. If you fail…I will make sure that both of your families

are thrown into the depths of the abyss of Barracura." He jabbed his reptilian finger toward them. The long talon at the tip had a greenish-yellow puss-like substance dripping off the end. The drops sizzled and hissed like acid as they hit the floor. They both dropped once again to their knees in fear with their faces bowed low, no longer looking at him.

"Yes, we will do exactly as you say, Lord and Master Abbadon," they said in unison.

Previously unseen, the pair of wings made of black mist unfurled and enveloped the Spectrarex. Khanon looked up just in time to catch a glimpse of the strange fiery Nossorads following after the beast as it vanished.

He and Sanwolf breathed a sigh of relief as the cold atmosphere slowly dissipated. Rising from their knees, they adjusted their vestments and composed themselves. They looked at each other grimly.

"A new religion from another false messiah. Why the urgency? There seems to be a new sect formed every day!" Khanon scoffed with a great deal of derision.

"I agree, there are hundreds of new religions established every year, yet this one is singled out." Sanwolf's voice was finally clear of the raspiness. They stood silent for a moment, observing the final containment module moving out of Khanon's transport ship.

Sanwolf moved closer to the Overseer. "Am I correct in assuming that I was included in that warning?" His tone was somewhat tentative, hoping he was wrong.

"You were included. But do not worry yourself, Brother Sanwolf, I have a plan to take immediate action." He turned to gaze through the transparent shielding, surveying the vast grounds. "I will garner the services of the Muak'Xod and Choshek organizations to assist in this matter," he stated with the utmost confidence.

"How quickly can you accomplish this?" Sanwolf's voice filled with optimism.

"Immediately." He turned to face Sanwolf. "Is there a closer secure location to view the removal process?"

"Yes, I have one not too far from here as a matter of fact." Sanwolf's demeanor relaxed a bit.

"Inform security to escort two guests to that location." Khanon looked once more at his ships.

"It will be done as ordered, Overseer," Sanwolf said respectfully, though in his eyes it was clear he wondered whom Khanon planned on summoning.

Chapter Six

HEDROPEX SPHERES

Inside a stark humid room, Gandu Khanon anxiously paced around the observation display console, watching the live 3D holographic feeds of the Hedropex sphere transfer process. Along with Synogog engineers of various disciplines were dozens of Tisradeen soldiers escorting each of the three containment modules, as the volatile cargo made its way to the waiting ships.

His focus was broken by hunger pangs. *Food will have to wait a little longer.* The removal of the Hedropex spheres from the Stadageos on Letalis and Necropis took precedence over everything else.

"They should be here any moment now," Khanon remarked about his summoned visitors, and wondered about this new religion that irritated the Tisrad Dragon to such a degree that a Spectrarex had been sent to them to ensure its demise.

Sanwolf remained silent nearby, observing the glowing containment modules making their way toward the ships. He shivered at the sheer power, then turned to Khanon and said, "I will go and escort our guests here."

Alone for the moment, Khanon placed his hands behind his back as he moved across the room toward a set of seats. "A new religion." His tone was contemplative. "One that must pose a great threat to the Kravjin Order," Khanon muttered with a slight derisive curl to his lip, being extremely mindful of what he said aloud, knowing that Nossorads reported everything they observed and heard to Abbadon. "That new sect will perish as quickly as it appeared," he said and glanced at the entrance of the room, waiting for the nefarious delegation of criminals.

As planned beforehand, he had become the primary benefactor of the two shadowy networks that would enable him to call upon their services at his discretion. Over the span of thirty years, he had unscrupulously grown the influence and reach of the Muak'Xod and Choshek networks. Transforming them from a loose association of thieves and assassins into cohesive powerful criminal organizations. Using his immense influence as their sole benefactor along with his position as an Overseer, he'd made binding deals with the leaders of the maleficent associations. In exchange for allowing the Choshek and Muak'Xod to conduct business without too much interference from the local governments, they would send their most accomplished agents to be vetted and trained by the elite special forces of the Krauvanok military to serve as the Overseer's private militia. His plan was to eventually use the uniquely trained agents to overthrow any neutral governing body or those aligning themselves with the Mantis Alliance. With Abbadon's recent decree to find and execute the Stadageo infiltrators and eliminate the new religion on Shalem, the time to call upon his private militia was at hand.

He sat in a seat that was more comfortable then it appeared to be.

He smiled with satisfaction, recalling the mission he had given to the Grand Dukar Ormaz Bharata, supreme leader of the Muak'Xod. He had been commissioned to travel to Ramah and activate his dormant agents and personally deliver to them a coded message. Almost nothing else would please him more than to see firsthand reports of the true pitiful state and ultimate demise of the sisterhood of the Marium Kahnet, no doubt the propagators of this new false religion. The destruction of these heretics who claimed that they had brought forth the true Messiah would bring him many rewards. He couldn't help but grin with the power and pride that flooded him at the thought. Straightening up in his seat, he tilted his head back and gloating laughter burst out. "Let all of their wombs bleed until the last drop of their life and existence is absorbed into the dust of history." The words left a sweet residue in his mouth, like a savory ripe fruit.

He a sensed a necronos life force approaching, then heard the doors smoothly slide into the walls. Entering behind his peer were his summoned guests. He stared piercingly at them, recognizing Dukar Tabor Gwauth, a prominent leader from the clans of Muak'Xod on Letalis, and the younger Medon Sotasen, a senior Choshek operative in the Letalis sector. They bowed and greeted him in the traditional Qwravasha fashion upon reaching him. "Mullgoth." He accepted their greeting with a wave of his hand, gesturing for them to be seated across from him. Sanwolf sat to his right.

"Before we begin, I have to make sure that you brought nothing with you that is not allowed specifically in this meeting." He stretched his arm out with his palm facing them and slowly closed it into a fist, and moved it from left to right in front of the two guests. "Sithgul

Tvesh," he commanded aloud. Small sparks of energy and puffs of black and grey smoke erupted from both Gwauth's and Sotasen's clothing.

"My deepest apologies on this oversight of protocol, my lords." Gwauth's swift response was clearly intended to excuse his blatant disregard for the presence of the weapons and listening devices. Both Kravjin members were unmoved by this disingenuous display.

Sanwolf raised his hand to stop the flood of lies from Gwauth. "Shall we just say this oversight will not be repeated?" His grim countenance underlined the seriousness of the statement.

"You are here on a most important matter. Political gamesmanship is irrelevant, so we will overlook the incident, this time." Khanon's blunt statement made it clear that he shared Sanwolf's sentiments. As they stared grimly at the agents, wielding an invisible sort of power, the room remained tense and charged.

Sotasen made no attempt to excuse himself; he merely nodded, as he had only done what was expected of a high-ranking Choshek agent. His stoic countenance reflected the same impervious surface as that of the chair he sat on.

The lights flickered, announcing that something very unpleasant would arrive shortly. They all looked around the room, wondering what was going on. *Is he back so soon? Will there be another command for me to follow?* Khanon cringed at the thought of another visitation from the Spectrarex. His heart began to pound and fear sluiced through his veins. He noticed the others tensing, preparing to defend themselves.

A fine black mist swirled over their heads, thickened, then a one-meter long deep red cylinder emerged from the roiling mist that intermittently flashed with fierce faces.

"Don't move or you will die where you sit!" Khanon shouted. *Spontaukar markers, what are they doing here?* These malevolent harbingers only appeared when someone was close to their death. The victim's soul would be taken to the realms of Creminmorta to exist throughout eternity as a slave.

Khanon started to sweat. *Is it here for me?* Swift relief came as he watched a black shadow rush at Sotasen, pass through him, then disappear. Sotasen looked stunned and sat panting lightly. He dared not say anything as he noted that Sotasen's forehead was marked with the symbol of Necrokeph, Spirit God of the Dead. It slowly faded, then vanished. *He or his forefathers must have partaken of the blood oath ceremonies. Now it's time to collect on what was pledged.* Khanon's thoughts troubled him, as he too had made similar oaths. He could only hope that the payment of souls would be several generations hence.

Just as quickly as the spectacle appeared, it vanished. They all remained silent for a moment, waiting to see what would happen next, if anything. Khanon tried to relax his shoulders, but the memory of the Spectrarex with poison dripping from the tip of its claw was fresh in his mind. It was a vivid reminder that none could escape the Tisrad Dragon's all seeing eye. He sent creatures to this realm at will.

"You are favored to witness the eternal powers that enforce the Chomtheke oaths," Sanwolf said proudly. "Understand you cannot

break the covenant between yourselves and the Kravjin. Any attempt to do so will result in a swift and painful death."

Although he appeared to remain stoic, Sotasen, like his peer, emitted unseen echoes of fear into the atmosphere.

"Do not be alarmed. You will not die…well at least not today," Khanon mocked, smelling the sour stench of fear.

He could see his remark did little to diminish their misgivings. The artificial red lenses in Gwauth's eyes evaporated from the sulfuric fumes during the visitation, revealing large streaks of blue that lined the black irises of his eyes. He swallowed hard; his face looked as if he'd bitten putrid meat.

"Did you really think you could hide this from me? I've known for years that you and a few others have been consuming Cymbratar," Khanon said with certainty and some irritation. "It is only now that you are marked. From this time forward, you will always get an unobstructed view of visitors from the realms of Creminmorta. Is that something that your supplier failed to mention?" Lifting his right hand toward the Dukar, he issued a grave warning, "Along with a handful of individuals not authorized to consume the substance, you will not be executed. But if anyone else, including your supplier, is caught, they will be publicly executed without trial or hearing. This command has been given directly from our leader and the Krauvanok Alliance supreme council. It cannot be changed."

"Understood, my lord," Gwauth said anxiously, clearly perturbed and frowning. This confirmed to Khanon that the information given to him by his agents was correct, that Gwauth would be meeting with someone to receive more Cymbratar. Agent Sotasen turned

toward the flustered Dukar and shook his head in disbelief at the Muak'Xod leader's blatant disregard of the Cymbratar decree.

With ears still ringing from the visitation, Khanon changed the subject. "Now, what word do you have from Grand Dukar Ormaz Bharata?" His mouth abruptly closed as his attention snapped to the base of the seats across from him.

Deep silence descended for a moment. Everyone's eyes fixated on the strange, partially transparent and fiery serpent-like creatures as they flitted around them. *Apparently they want to be seen by those in the room*, Khanon thought. Judging by Gwauth's rigid appearance and Sotasen's somewhat alarmed gaze it was clear they had never seen these types of creatures.

"They are called Nossorads, from the kingdom of the Tisrad Dragon." Khanon grinned as he surreptitiously used his gift of spiritual discernment to search for the presence of the Spectrarex. "Do not be alarmed." He patted the air in front of him. "They are our guests." It was apparent that Gwauth was not convinced.

"Do you have word, Gwauth, from your operatives on Ramah?" Sanwolf pressed the disturbed Muak'Xod leader.

Gwauth coughed, seeming to almost choke for a moment, before he replied. "Yes. I have word that the citizens of Ramah hold the Marium Kahnet responsible for the attack decades ago. Some in authority wish to prosecute them for war crimes," he said with a grin on his face.

"Very good. Public prosecution of war crimes against the Marium Kahnet will most certainly send them straight into oblivion." Khanon

grinned, rubbing his hands together with the anticipation of his dream coming to fruition. He turned to Sanwolf, who grinned in return. "And now on to other matters more pressing at the moment. In respect to our Chomtheke covenant, I want you to assist those within the Shalem government positions willing to join the Varkrato League to obtain higher positions of influence."

With a small pause, he leaned back, exerting his the full authority. "You will start a civil war. I will order the mobilization of my militia from both respective associations to assist you to quell any resistance of the Shalem governments and military. You will all take direction from my military commanders." His stern countenance was threatening and he leaned forward, using it to his advantage. "At the same time, you will eliminate a new zealot sect known as 'The Way.' They claim to follow a so called messiah, Meshua." He scoffed. "Kill the founders, their families, and their followers, and cast the blame of the civil war on them." His haughty laughter filled the room. "The code name for this operation is Shalem Liberation."

He received nods of acknowledgement from his two guests as agreement with the plan. But Gwauth's eyes followed the movements of the strange menacing creatures hovering over their heads, irritating Khanon, who narrowed his eyes. Noticing, Gwauth quickly responded to the command. "We will honor and fulfill the blood oaths between us," he said loudly, trying to emulate Khanon's demeanor.

Sanwolf turned his attention to the senior Choshek agent, Sotasen. "As proxy for the Grand Dukar Droden Namtar, you have the right to speak on his behalf." His eyes stayed determinedly away from the air above the agent's head, where a Nossorad glared menacingly at him.

Sotasen nodded in acknowledgment and slid the hood of his cloak off of his sleek bald head. "I will of course, on behalf of the Choshek association and our family clans, fulfill and honor the blood covenant between us." Each word was spoken with emphasis to his absolute resolve.

"Is there anything else that my lord commands us to do?" Gwauth asked earnestly.

"Yes, but I sense you have something to impart to us," Khanon said with a wry smile.

Gwauth nodded. "There is some information that I would like to share with you." He darted a quick glance at Sotasen, then back to the Overseers. "This is also for our Choshek guest to hear."

Khanon remained silent, merely lifting an inquiring eyebrow, giving Gwauth a swift upward nod to show his interest.

"I have information from a very reliable source within the high ranks of the sisterhood that Jazrene Vallo, the leader of the sisterhood, has authorized Lakad. The Lakad authorizes the sisterhood to hire mercenaries to track down and bring rogue sisters back to Ramah, dead or alive. As you well know, these rogues have been seeking revenge for what happened on their home planet many years ago." Gwauth paused and waited for a response.

Sotasen looked at Gwauth, then addressed the Kravjin sorcerers to break the silence. "I understand that most of the assassinations of Qwravasha members were not politically motivated, but were actually the result of these rogue elements of the Marium Kahnet seeking retribution," he said in an emotionless, factual tone.

Gwauth continued in the same vein. "I know, as a matter of fact, a few of them were caught several years ago, just outside the regions of the Rakia Expanse. They were interrogated by the Sadruk authorities but refused to talk. Of course they were publicly executed." His eyes gleamed with malevolent derision.

"Too bad I was not there to assist. I have no doubt that if I had them in my grip…they would talk." Sotasen's boast rang with conviction.

Dargo Sanwolf's bark of laughter drew all of their attention "Don't be deceived by their fragile appearance. Your arrogance is misplaced. Although the Marium Kahnet are known by their benevolent care of the masses, don't be misled by the public's weak sentiments. The truth is, those in the sisterhood are trained physically and mentally to such a high degree, they can withstand a great deal of pain by isolating and dampening any nerve sensation in their bodies. Another little known fact is that they have the ability to neutralize mind-altering substances and neurotoxins by modifying their chemical makeup using some sort of inner spiritual powers. Moreover, they are taught Krav Naga, the lethal fighting style used by the Mantis Alliance forces. I warn you both, these women are not as helpless as they appear."

Sanwolf wagged a finger at Gwauth and Sotasen. "I speak from experience. These rogues you mentioned were the very ones caught trying to assassinate me. I was surveying a series of planets for suitable places to build new Qwravasha temples just outside the Rakia Expanse. On the last planet, as I was heading back to my ship docked in a large refueling and repair station, my intelligence agents captured five of them. They were cleverly disguised as ship

maintenance and repair crews. After days of grueling interrogation, I decided to have them publicly crucified for their attempt to murder a Qwravasha high priest. This action served as a grim warning to the public and the surrounding sectors of space of the dire consequences to any who would aid and abet the rogue faction that the same fate would befall them."

"I appreciate the information about them, Lord Sanwolf." Sotasen nodded his head approvingly. His eyes were alight with curiosity and determination.

Khanon felt somewhat nauseous. "Tell me the details of Lakad, and the whereabouts of the rogues." He gulped hard, as the thought of rogues having access to his project brought dread and the threat of dire consequences to him. "Do not fear, I already know, but I would like confirmation for a certainty." He nodded his head encouragingly.

"Very well, Lord Khanon… my operatives recently informed me that their hired mercenaries are heading to this region of space," Gwauth said carefully. Khanon sensed he was only imparting a small portion of his intelligence reports. But it was enough.

His mind spun with speculations. *This confirms the Spectrarex's assertion that there are enemy spies hidden within my projects. Those hired mercenaries are headed straight here.* "Sotasen, after Liberation Shalem has begun, I want you to bring a team comprised of your best agents here and report to Lord Sanwolf. Your team will screen all individuals who have access to the Stadageo complexes here on Letalis." The Overseer crossed his arms over his chest.

Sotasen's face was aglow with pride. "It will be my honor, Lord

Khanon," he said in a somewhat gloating tone. Gwauth, as the Muak'Xod leader, did not look pleased with the directive to have a competing association operate openly on his home world.

"Gwauth, I expect that your clans will do their part in operation Liberation Shalem," Khanon continued. "I want you to gather a contingent of your best agents and have them report to Lord Fabix Tagran on Necropis. This might seem unorthodox, to have teams on each other's home world, but I have my reasons for doing so. If anyone has any objections, they will find themselves encountering a Nossorad or Abbadon himself." His stern face was immovable, as was his resolve.

"As you wish, Lord Khanon." Sotasen respectfully nodded, acknowledging his acceptance of the commission.

Gwauth also nodded in kind. "It will be my honor to do so, Lord Khanon."

They all surveyed the room, searching for Creminmorta beings, but they were gone.

"So, if there is nothing further to discuss, this meeting has ended. You may leave us now to attend to these urgent matters."

Sanwolf and Khanon rose. Gwauth and Sotasen immediately followed suit. "Mullgoth," the two spoke in unison, issuing the customary accompanying fist cupping salute, and left.

Khanon made his way to the round metal table and waved his hand over a panel, which activated the display screen. A satisfied smile lit up his face as he noted that all three transportation modules had been successfully secured onto their ships. With another series

of command entries he activated a communications screen. A moment later the solemn face of a Synogog commander appeared. He addressed the middle-aged humanoid woman. "Greetings, Commander Tvek. Status report."

"Lord Khanon, we are leaving Necropis and have successfully powered down the dark-matter power matrix cores and are heading back to Tartarus, as you have instructed," the light green-skinned commander replied.

"Good. I am leaving Letalis and will reach Necropis shortly. Once all of the Hedropex spheres are secure, we will continue on our way to Tartarus. Prepare all personnel for re-assignment when I return." He sucked in a large relieved gulp of air.

"As you command." She nodded stiffly, then signed off.

Khanon moved his hand to the far left of the screen and touched a brightly flashing symbol. A multi-faceted striking and youthful holographic image of Alexia Meega, the pilot of his ship, appeared. "Yes, my Lord Khanon." She looked expectantly at him as she awaited her orders. The young prodigy had already amassed vast amounts of experience at the helm of large transportation ships for a mineral organization on Tartarus when she had caught his attention. He had been searching for additional pilots for the Leviathan project at the time. After a comprehensive and exhaustive security background check, it was apparent that her intuitive flight skill and mental aptitude had been passed down to her through the Meega family bloodlines.

"Inform the other two ships to prepare for departure. Our new destination is Necropis."

"As you command, Lord Khanon."

He nodded his approval and waved his hand over the panel to deactivate the screen. Satisfied that all was going as planned, he strode toward the open doors, where Lord Sanwolf waited to escort him back to his ship.

Through the viewport of the shuttle, the velocity of the snow and ice pellets carried by the swirling high-speed winds of a blizzard limited visibility to several meters. The automated pilot of the small vessel announced the distance to the ship every hundred meters until it finally came to a full stop.

Between thick waves of blinding snow, Khanon could barely see the dark silhouettes of soldiers in their universal atmospheric full body armor, as they boarded his ship. The shuttle's pilot had been ordered to hover near a specific access door of the specially constructed chamber, where the multi-phasic transportation module was stored. He would board the ship there to inspect the cargo. Heavy snow flurries wafted across the ten-meter distance between the shuttle and the ship.

He turned to face Sanwolf and the other priests who had rejoined them. They spoke as one voice, "Mullgoth," to the Overseer, who returned the salutation.

Standing at the edge of the open door, he chanted aloud in the dark speech of Toxrokk. At first Khanon's words were clear, but they were quickly muffled by the howling wind. To no one's surprise, he

walked with confidence out into the open space and vanished into a thick white haze that blew between the two vessels.

Chapter Seven

REDIQUIN

"Approaching Necropis orbital security checkpoint. Arrival in .5 QST."

The female voice repeated the announcement twice before Tvene Sotasen opened her eyes to a colorful array of flashing lights on the main control panel. Smoothly, she slid her hand under the armrest of her chair and pressed a button, which repositioned the chair into an upright configuration. Gathering up the hooded cloak she had used to cover herself, she tossed it onto the armrest of the co-pilot seat to her right.

She gazed out of the bridge viewport, then, as was her custom, stood up and moved between the two seats. With palms touching above her head, then sweeping inward toward her chest, she began to move her upper and lower body in precise graceful movements. "Moshiach is my center. I see my life as still waters," she whispered throughout the Kohyim serenity routine.

Feeling rejuvenated and refreshed, she resettled herself in the plush seat of her prized Guyyian-built stealth ship, the *Furies Scepter*.

She had acquired it using wealth from her signature smuggling trade of the highly sought after and exorbitantly priced substance, Cymbratar. The extremely lucrative bartering of the rare substance was the primary resource that funded the elimination of her targets throughout the vast regions of the Rakia Expanse. Reaching to the right, she touched a hidden button just below the main control panel. It hissed as a thin plate slid out that held an elegantly decorated containment box. She smiled appreciatively with the thought that it would soon be filled with the coveted substance.

The opportunity to grow her reputation as a master in the illegal trade of Cymbratar had now spread to the Malgavatta galaxy. A wealthy client there had just given her a handsomely large down payment. She tried to wrap her mind around it. Even after years of thorough investigation, the mysteries of the substance still eluded her. She knew little more now than she did years ago, save that Cymbratar contained trace minerals and spiritual elements taken from the realms of Creminmorta. This was the primary reason it was impossible to replicate. It was mostly consumed by those in highly skilled positions within the Stadageo projects, ensuring that the talented and skilled workforce stayed healthy and strong during the project's life cycle. As always, she took extreme caution when trading Cymbratar, very aware of the danger. In the back of her mind loomed the consequence of public execution if she was caught trading in it. She stared at the empty box, then with a shrug of her shoulders set aside her hopes of discovering more details of how the substance was made for the moment.

The no tolerance enforcement policy of Cymbratar law, over time, had created a deep sense of unquestioning loyalty of the users

to their taskmasters, because of the seductive side benefits. The exotic gel capsule assisted in the retention of youthful appearance, increased strength, and in a few instances vastly increased acumen. Tvene had seen the immediate and almost miraculous effects of consuming a minute amount of the substance and had wrestled with the temptation to use it for herself, at first. Eventually self-justification, logic, and reasoning of her need to take it had won over her spiritual inclinations and convictions and she began taking it. After all, the strategy of building a reputation under her mercenary name, Rediquin, as an elite super-agent would take years if not decades. Early on, as she began trading the substance, she learned firsthand the consequences of ingesting too much of it. Her associate Dmaux Amamet disregarded the warnings, relegating them as fables to scare off unauthorized use. Unfortunately, he realized too late that taking more than one portion caused irreversible malfunction of vital organs and inevitably led to his very painful death.

Now, after many years hunting those responsible for the infanticide and mass murder of entire families on Ramah, including hers, she had honed her skills. She exacted revenge on her targets like a master craftsman of death, swiftly and silently in the background. She masked her true motives from others by assisting a long and varied list of benefactors whose assassination targets at times were Qwravasha priests. Her credo was: "The hand that plunges the blade satiates the hunger of revenge." She made it very clear to her clients that they would have to finish what she had craftily put into motion, effectively distancing herself from a direct connection to each event. Although her hands were not directly involved in the assassinations, she knew in the depths of her soul that she was equally culpable.

Once she arrived on Necropis, she would signal her client, Tabor Gwauth, and arrange a rendezvous. He had hired her to frame Ormaz Bharata as a traitor. This ultimately would make his transition to the seat of Grand Dukar of the Muak'Xod organization a much less hazardous one, or so he hoped.

Staring out into deep space, she envisioned the faces of the sisters on Letalis, and wondered when they would request her services. Her elaborate network of contacts had yet to yield a coded request from them. *If they want me to eliminate someone, they'd better do so quickly. Jazrene Vallo has obtained the services of outer rim mercenaries for their capture.* She cringed inwardly at the feelings the name evoked in her spirit. *It's too late to go back to Ramah now.* Briefly closing her eyes, she shoved the loss deep into the recesses of her mind and heart.

The ship made a course correction, approaching Necropis near its equator. "I'll find you first," she said with fresh determination, because the bounty hunters were also looking for the rogues on Necropis as well as Letalis. Thankfully, she had enough Cymbratar to unearth the necessary clues to their identities and whereabouts. *I know some of the cadre of mercenaries on the hunt. They are surely close to their targets by now. So how am I going to warn the sisters on Letalis while I search for the others on Necropis? I don't mind them being taken back home. But I want the opportunities provided through them to eliminate very prominent Qwravasha sorcerers.*

"The top of the list is Gandu Khanon." The dark tone in her voice cemented her rage against him. He was her most desired target and also the most elusive. She folded her arms across her chest. "This will be somewhat of a challenge." The obstacles posed by Dukar Gwauth's deployment of surveillance operations during

their meeting, in the effort to discover the source of her supply of Cymbratar, posed a very small challenge. She released a burst of haughty laughter at his pitiful ploys. "You're not good enough, Dukar Gwauth, to catch me, a master agent." She scoffed.

Her large blue eyes darted to a series of blinking lights on the control panel and then toward a Necropis orbital security checkpoint as she passed by it.

A computerized voice said: "Necropis government prohibits the use of cloaking or masking technologies during your ship's approach or departure. Any violation of these restrictions will result in the confiscation of your ship and the captain of the ship will be held criminally responsible—"

Rediquin reached to the far right of the main control panel and switched off the automated warning. She was secure in the knowledge that she would not be detected, thanks to the *Furies Scepter's* highly advanced cloaking and masking drive systems. This technology was surpassed only by the Krauvanok and their mortal nemesis, the Mantis Alliance. "I wish it was still spring," she remarked, noting the cloudless continent. She slowed the rate of descent to dampen any identifiable heat signatures that would alert the authorities of her illegal entry.

What should I do? Her soul groaned in commiseration, torn by the need to make a decision. *I want to warn the sisters about the bounty hunters, but I also have my business to attend to in the Malgavatta galaxy. If I fail to deliver to my new client on time, my reputation could be irreparably damaged.* Corralling her misgivings, she cleared her mind once again and let the concerns drift away. "My reputation comes first. Besides,

they will be home where they belong," she said defiantly.

A string of cryptic symbols appeared across the top of the display screen. She quickly deciphered them. *So, the meeting is going to be there. Good, it's near my first appointment.* "That will certainly save me travel time." She spoke softly as her agile mind sought potential dangers she could face at the meeting place. The brownish and lackluster color of the plains below indicated her least favorite time of the year.

Rediquin removed her body armor and donned the unique lightweight Opoline clothing that was as strong as some metals. It kept the wearer comfortable in various climates to a certain degree, while offering protective shielding from small arms fire. Her left hand slid into her vestment and retrieved the AR57 energy pistol and lightly palmed it. A quick inspection showed her it was fully charged and ready to discharge its deadly energized pellets. She enjoyed her ambidexterity, playfully tossing the weapon into the air, and with an expertly directed dart of her other hand snatched it mid-arc before just as quickly tucking it into the utility belt beneath her cloak. Her full lips lifted in a mischievous smile, which disappeared as an array of brightly flashing multi-colored alarm beacons lit up the control panel.

"Not now," she blurted in frustration as the cloaking and auxiliary energy systems began to fail. Fortunately, she had a small cache of replacement parts for every possible component failure aboard ship, as it was her nature to form contingency plans. She would need to land soon and quickly make the repairs to remain hidden.

The ship slowed considerably as it approached the landing

coordinates. She deactivated the autopilot and expertly maneuvered the ship manually through a narrow ravine, safely landing on a narrow ledge jutting out of the side of the rusty red and grey mountain. The bridge lights dimmed as the ship powered down. She retrieved the Cymbratar container and slipped it into an inner pocket, secured it with a flap, and patted it with satisfaction. She then retrieved a small black box from under her seat and placed it in her utility belt.

With the environmental systems offline, she could smell the burnt circuitry. "I better make those repairs," she said drearily and headed straightaway toward the engine compartment.

The dim lighting notwithstanding, with her Cymbratar enhanced vision and thorough knowledge of every square meter of the *Furies Scepter*, she easily navigated the various storage shelves. "Here you are," she said, and slid on protective gloves. Moving with nimble dexterity, she removed the shield plating of the cloaking and masking drives. Her head reflexively jerked back as a blast of heat and the smell of charred components hit her face. "Just as I thought." She coughed, lightly expelling the smoke.

Turning her face to the side, she breathed a bit of fresh air, held it, reached into the opening, and deftly removed the damaged masking drive distribution nodules. The heat emanating from the overtaxed components washed over her face and her eyes watered from the lingering toxic fumes. Her nose wrinkled as she suppressed the urge to sneeze. "Aahhh, that's bad." She stood up and took a step back. "At least these are still worth something." Her optimistic statement made her feel better. She briefly inspected the damaged parts, then, deciding they could not be repaired, tossed them into a self-sealing

storage container. Wasting no time, she immediately installed the new components.

Satisfied she was done, Rediquin glided her hand over the sleek hull of the ship. "There you go, my dear friend. You are all better now!" She spoke fondly to the trusty machine that had faithfully helped her escape many perilous encounters over the years. The vast distances and dangerous paths that she traveled in her particular type of business had caused a lot of wear and tear on the small vessel, necessitating a steady flow of repairs. "I am going to need another set of cloaking and energy masking flux regulators for you very soon." Although she had spent enough resources to buy a small fleet of civilian transportation ships, the idea never dawned on her to buy a newer model. Still, it was clear to her why there weren't more mercenaries or agents like herself, who possessed these types of Guyyian-built shadow ships. The cost to maintain these systems alone was exorbitant.

Standing by the open cargo bay door, she rechecked her weapons and gear, then jumped onto an old narrow hover bike. "Secure Furies Scepter," she said into her wristband. The ship vanished from sight and she sped down the mountain to the first meeting of the day.

The Weapons Energy Detection Optics (WEDOs) she wore looked like ordinary anti-glare optical wear to most, but were actually Choshek agent devices that enabled her to detect the minutest weapons energy signature. After leaving her hover bike in a small town transportation hub, she boarded the public shuttle service to

travel several hundred kilometers south of the Thrawngu mountain range to the Aphasium market place. Easily blending in with the bustling community, her heightened senses picked up the pockets of malodorous scents of the kaleidoscope of strange humanoid life forms and other sentient beings she passed. With short bursts of controlled breaths, she made her way through the milling crowds, ignoring the unpleasantness. As expected, her WEDOs picked up dozens of weapons signatures. Most were in the vicinity of the proprietors standing watch under shaded awnings, in front of their exotic produce and handcrafted wares establishments. She also knew that some of the merchant stores were fronts for the criminal elements, more specifically the Muak'Xod, the largest and most influential shadow organization in this region of space.

Only one more cluster of ramshackle storefronts stood between her and a fresh supply of Cymbratar. Her footsteps slowed as her WEDOs picked up a very tight cluster of energy signatures sixty meters in front of her. Experience told her it was an impromptu security checkpoint due in part to the presence of the Synogog or the Krauvanok Alliance Overseers.

Noticing a narrow path behind a movable three-meter high display, she moved casually toward it to escape detection from any hidden Necropis government agents in the crowd. With perfectly timed movements, she blended in with a group of human females headed straight toward the beautiful display of multicolored fabrics that gleamed in the bright sun. *Made it*, she congratulated herself and inserted herself in the midst of them. A couple of them darted suspicious glances at her, but she remained calm, fingering the fabric right alongside them. Then, as quickly as possible, she slid through

the narrow space behind the display and strolled nonchalantly down the alleyway. With furtive glances upward at timed intervals, she scanned the ledges above her for enemy agents or signs of surveillance device activity.

This is not the most optimal place if I have to defend myself. The pathway felt constricted as she made haste down the two hundred meter long path. Just ahead was another temporary two-meter high display, wider than the first one, spanning the length of the two buildings and leaving no room to pass inconspicuously through. "No choice," she said grudgingly. Reaching into her cloak, she retrieved a small flat metal device and glided it across her WEDOs, which activated it, then placed it on top of the display.

A brief moment later, the area on the other side of the display appeared in her WEDOs. Determining that it was mostly clear of danger, she retrieved the device and deactivated it, then slipped it back into her vestment. "Here we go," she said, trying to stay positive. She backed up, then ran with a short burst of speed to one side of the display, vaulted up with all her enhanced strength, firmly gripped the top of the display with her right hand, and simultaneously pushed off the side of the building with her right foot, leveraging her body over the top of the display. Landing gracefully on the other side, she rose from the slight dip of the landing and blended in with the moving crowd without a pause.

This was the long route to her appointment, but thankfully it was in the more pleasant sections of the market, which held the bounty of midsummer fruit. The aromas of Augaberries and other sweet and ripe offerings tantalized her senses and triggered a growl in her stomach, reminding her that she had not eaten for some time.

Hunger aside, her sharp vision picked up several miniature data drones heading in her direction, gliding along the surfaces of the roofs, no doubt scanning the faces of the individuals. *Apparently my move over the display has not escaped notice.*

A reflective glimmer of light from a mirror fifty meters away caught her attention. Dismissing it, she continued to walk among a crowd of merchants and buyers in animated conversation, moving her head casually from side to side, trying to avoid being identified by the surveillance drones. A second bright flash was directed her way, then an insistent third flash. *Must be my contact*, she thought, sliding her hand to the butt of her AR57 pistol, carefully reading the display of her WEDOs.

Sensing no immediate danger, she proceeded to the entrance of the establishment where the bright flash had come from. Once inside, the aroma of fresh produce on the shelves lifted her spirits. With her right hand still on her weapon, she walked between shelves stocked with various types of bread.

From the rear of the store someone addressed her. "Nice to see you again, Rediquin."

She was relieved somewhat to hear the familiar voice of a fellow agent and respected peer, and confidently strode to the rear of the empty store. Her contact, Zeta Three, pulled on a thick rope and tugged the thick curtain closed behind them, creating a more private space. Rediquin pushed the WEDOs up to the top of her head and grinned. "It's nice to see you again." She raised her brows inquiringly and placed her hands on her hips.

"I knew about the checkpoints, so I set up a makeshift detour that

I knew you could manage," Zeta Three said warmly. His deep green eyes had streaks of blue, the mark of Cymbratar consumption. They had a lot in common; as a fellow mercenary, he also had loose affiliations with the Muak'Xod network. He extended his left gloved hand to receive his merchandise.

"It's all there, as you requested." She referred to the detailed plans to build a Stadageo on the black metal cube she had retrieved from her utility belt, and dropped it neatly into his palm.

He lifted an eyebrow as his right hand skimmed over the box. His wristband lit up, verifying key aspects of the data. The satisfaction was clear on his dark countenance; the thin smile parted the individual strands of the rather sparse facial hair on his top lip, making him look more youthful than he really was.

"And the power source to run it?" She wondered how they were going to duplicate the unique energies to create hybrid soldiers as generated by the Hedropex spheres. Her statement hung in the air for a moment.

"I have been informed by my benefactors that it can be accomplished." Zeta Three's tone was confident.

"Seems improbable, but if you need assistance with executing the nearly impossible, you can ask for my help, anytime. For a price of course." With that said, she slid her hand into the hidden pocket in her cloak and retrieved the empty Cymbratar container. He removed the glove on his right hand and pressed his right index finger on the top of the ornate lid of a similar looking container in the palm of his left hand. The top retracted smoothly, revealing dozens of dark red oblong gel capsules that sparkled in the low light of the back

room. The glistening effect was from elements obtained from dark realms of Creminmorta that were melded into the Cymbratar. She leaned closer to inspect the tiny treasures, then, using her thumb and index finger, gently transferred them one by one into her own container.

"I am not sure if I can get more for you. As you are aware, the Stadageo projects are being shut down as we speak, which means the production of Cymbratar will greatly diminish or completely cease." He looked at her piercingly, as if trying to read her mind. She nodded in agreement, confirming what she had gathered from various intelligence sources.

After the last one was placed in the container, she sealed it and then pressed a button on the top right corner, activating its internal bio-molecular energy mass scanner. A moment later three green overlapping circles appeared on its lid, authenticating its contents. Truthfully, Rediquin was not concerned about the supply of Cymbratar drying up because she had stashed away enough of the regenerative substance over the years to buy a whole planet if she desired.

Rediquin looked at Zeta Three and flashed a mischievous white smile. "That's okay. I am sure that I will find something else to sell." She broke eye contact with him and slid the ornate container and its precious contents into her cloak. A hint of the rare moment of light-hearted banter during the business transaction still lingered. Noticing his continuing attention, she tilted her head to the side and waited. His expression was inquisitive and held a somewhat enamored look as he gazed probingly into her eyes. She felt his interest but was unwilling to respond in kind.

"Don't be surprised if I contact you for a job," he said with a knowing inflection in his tone. "Well... until next time then." He bowed his head, somewhat reluctant to leave.

"Until then," she returned.

He spun and disappeared through a narrow door in the back of the store. Rediquin also made haste to exit and headed toward the next sector of the city to meet Dukar Gwauth.

As the heat of the day dissipated with the approach of evening, the moderate temperature allowed more visitors to shop comfortably. The crowds had multiplied, and Rediquin used the increased activity to survey the area where the Muak'Xod leader was waiting for her, making sure she would not be taken by surprise. Satisfied that it was safe, she made her way to a small makeshift tent nestled in between two buildings.

Her senses went on high alert as the WEDOs identified two prominent and unique weapons signatures within the flimsy flapping canvas walls. She glimpsed the Muak'Xod agents in full body armor as she ducked under the fabric and entered. The two immediately positioned themselves several meters behind her as she passed them, standing guard. Her senses were at their maximum peak. Her hand mildly twitched on the butt of her AR57 energy pistol, ready to discharge its deadly energy on anyone who dared to touch or attack her as she stood in the center of the tent. The stillness of her stance was deceptive, as she could strike in any direction without notice, suddenly springing into action. She waited for the lean man clothed

in the typical Muak'Xod attire of a Dukar to summon her forward.

"Please come in and be seated." Tabor Gwauth gestured to a single empty chair directly across the table from him.

The two agents remained by the entrance. Her heightened senses picked up their restive movements. She recalled the discussion she'd had several weeks earlier with Droden Namtar, the Grand Dukar of the Choshek clans. He had given her permission to proceed with Gwauth's elaborate scheme to implicate and frame Ormaz Bharata as a traitor, which would allow him to ascend to the seat of Grand Dukar of the Muak'Xod clan. Unbeknownst to Gwauth, the two Grand Dukars continued a decades old secret pact to refrain from intervening in each other's internal power struggles within their respective family clans. Especially plots involving the high-ranking positions of their criminal organizations.

Rediquin fluidly perched on the edge of the seat, lightly pushing the chair backward to give herself room to maneuver, if necessary. As soon as she settled, the treacherous Muak'Xod leader placed his hand on the right corner of the table. A short burst of charged air crackled as a familiar bluish dome engulfed them with a secure listening device-free zone.

"Greetings, Rediquin. Let's get to business, shall we?" He noted her nod of acknowledgement with a slight dip of his head in return. "I know you are here to continue our negotiations, but certain events and circumstances have come about. Ones that are advantageous to me and my plans," he said assertively, leaning forward and tapping his chest. "Ones that will necessitate your actions sooner rather than later, as we had previously discussed. Things have lined up that will

make your job much easier." He smiled thinly.

"If I accept your contract now, it will greatly disrupt my current mission," she replied slowly, giving herself time to discern what he was up to. She was curious to hear what had changed that necessitated the implementation of his plan immediately.

"I will give you tenfold in the final payment if you start our deal immediately." Now his smile exuded confidence. He knew that she would not be able to resist accepting such a vastly rewarding contract.

Rediquin ground her teeth together, struggling momentarily with the idea of delaying delivery of the precious cargo to her new client. But the amount of money he was pledging was the largest prize she had ever been offered. *All I have to do is give my new benefactor a discount for delivering the Cymbratar late.* With that thought, she convinced herself to take the job.

"I will accept the contract." She leaned forward and her face hardened with a glowering stare. "I must warn you, it will be very difficult to move against Ormaz Bharata. He is, after all, the Grand Dukar of the Muak'Xod clans." He needed to understand the severity of the risk he was taking.

Gwauth looked indignant momentarily, then a sly look slid over his face. "Of course, as we all know the rewards that come with great wealth can bring miraculous results for the both of us. Speaking of the expedited plans." He smiled again, revealing his glowing white teeth.

She quirked an eyebrow, waiting for him to continue.

"It has come to my attention that there are enemy spies within the Stadageo projects on Letalis and Necropis. This has, of course, been verified by very reliable sources of which you would not be aware of." His arrogance and dismissive words did not move her in the least. Her expression remained impassive and unperturbed. "To be more exact, there are mercenaries outside of my sphere of influence whose mission is to capture these rogue factions of the Marium Kahnet and bring them back to Ramah."

His reflexive tapping on the table to emphasize his points was mildly annoying, but her direct gaze remained fixed on his, listening to his words and discerning him.

"My guess is that the rogue sisters will most likely try to damage the Stadageos sometime after they are shut down," he drawled. "I want you to come alongside of them." He paused, then darted a suspicious glance over her head at the guards as if they could hear. "And help them in their endeavor." His voice was quieter. "When you find them, make sure they understand that you were given authority to assist them by the Grand Dukar, Ormaz Bharata. Then, before they take action, you will inform the proper authorities of this conspiracy, casting the shadow of collusion with the enemies of the Krauvanok Alliances and powerful supernatural forces that you can't comprehend." He grinned widely, as if he were already holding the prize he sought. "Given the fact that he is already on his way to see the Marium Kahnet's leader, Jazrene Vallo, this will seal his fate as a traitor to our clan and will force the hand of Gandu Khanon against the Muak'Xod leadership to execute him or at the very least relieve him of his position as the Grand Dukar." He leaned back in his seat and clapped his open-fingered hands together, making a dull

thud as if closing an animal trap.

Rediquin remained impassive until her spiritual discernment made her aware of a cold presence that had entered the tent. Outside the dome engulfing her and Gwauth, a black spot quickly grew to a threatening size.

She surreptitiously tightened her grip on her weapon, preparing to fire if necessary. "A friend of yours, Dukar?" She kept her tone light, trying to show she was not greatly disturbed or surprised by its appearance.

He turned to look at the strange black, mist-like apparition. It stopped its forward advance, piercing the outer portion of the dome, and partially materialized, exposing its fangs. The creature's wraith-like countenance grimaced cruelly at them and then vanished.

"I see what you mean by forces that I do not understand," she said, impressed with his alliance with the Tisrad Dragon. "As I mentioned before, those forces will want the heads of those conspiring against them. Grand Dukar Gwauth has a nice ring to it, don't you think?"

He bared his teeth and tossed a metal cube at her. She snatched it out of the air so quickly it was a blur. "That contains the necessary information to obtain what you need to create an effective plan to damage the Stadageos." He leaned forward confidingly and the chair creaked with the shift of his weight. "Remember, you will be paid very handsomely."

Rediquin's spiritual discernment was able to enter the windows of his soul. The probing revealed his true self as one with little substance of character and about as much honor. His promise of

riches was more of a promise of certain death, hers to be exact. She was unconcerned, as she had other means of extracting payments regardless of who the debtor was. To her good fortune, she had been told by the Grand Dukar, Droden Namtar, that Ormaz Bharata would surely give her a reward for revealing this plot. *It's your demise, Dukar Gwauth. Great wrath will surely fall on your head,* she thought with derision, but outwardly gave Gwauth an agreeable nod of her head.

"Keep me informed as best you can." His grin was mere show, with no warmth whatsoever.

"I will do what I do best and you will get the desired results you ask for, Dukar Gwauth." With her bold statement, she stood and waited until he disengaged the privacy dome. "Now, if you will excuse me. I have a very short period of time to accomplish a great deal."

He gestured toward the opening behind him, dismissing her. She bowed her head and strode out.

Aided by the light of a Necropis moon, Rediquin easily navigated through the ravine atop the hover bike, then pulled back on the throttle as she closed in on her ship. "Home," she said aloud, and the *Furies Scepter* de-cloaked. With a maneuver practiced many times before, she guided the hover bike through the open cargo bay door and powered it down and jumped off it. She watched it slide across the floor until it tapped the hull on the other side. She laughed aloud. "Secure hover bike Furies Scepter," she commanded loudly. She executed several advanced Kohyim stretches then made her way

to the bridge and slumped into the pilot's seat.

Leaning slightly to her left, she reached under the seat and retrieved several Tisradeen Energy Protein Packs (TEPPs). She ripped the packages open and unceremoniously ate them with such speed and urgency that she had to stop, with her mouth full, just to take a breath. Slumping back, she laughed at herself for the ravenous way she was eating. Almost immediately, she felt the regeneration of the combat super food course through her body. She reached down with a sigh and picked up a cylindrical flask, opened the top, and drank the nutrient and electrolyte rich Kravajava, the lightly sweetened water-based liquid that, paired with the TEPPs, filled her stomach after what had seemed like weeks of deprivation.

Her plans to travel into the vast and mostly unexplored regions of the Fortuu Expanses of the Malgavatta galaxy to deliver her precious cargo had been altered. *I had no choice in my decision. The reward was far too large to resist. With so many dangerous individuals seeking the rogues' capture, it only makes sense to accept Dukar Gwauth's offer. With my help maybe they will live and not die.*

Her thoughts lingered as she powered up the ship, setting course for the other side of Necropis to pick up her emergency stash of Cymbratar. As the ship lifted off and sped over the mountain, she mentally formed a plan to find the sisters on Necropis and warn them. The precise time to double cross Dukar Gwauth would become clear to her, she knew by instinct. She glanced through the viewport, watching the city lights fade into the distance. "What about Nia and Taona on Letalis?" Her voice held the distress she felt about their plight. *I wonder if there are any sisters on Tartarus*, she pondered grimly.

Coming to a decision, she reviewed the latest reports from her network of indebted informants. *They are shutting down the Stadageo during the official transfer of ownership to the governments of Letalis and Necropis.* Her brow pleated as she read the information.

"No more Cymbratar... I need to find these sisters quickly. I believe it's time to call on favors owed."

Chapter Eight

LEVIATHANS

Aboard a Krauvanok Alliance military ship, Balese stared into the vastness of space, and was thankful that the Stadageos were shut down. To her right, just visible in the near distance was the nebulas cloud that hid the Mecropex facility, and the heart of the Leviathan where she and Victoria had spent a better part of four years.

"The time has come," she whispered. *Now I lay down my life as a willing recompense. For the cries of the inconsolable have demanded payment from the hands who craft cruelty. Like a mid-wife whose hands crossed over the threshold of the abominable, I have brought forth through the breech of Creminmorta the brood of unholy creations. Their birth has stained the hands of my spirit and my soul was gripped with paralyzing fear and terror as I looked into their merciless eyes.* Balese's thoughts were broken by someone approaching from behind her, but she remained at ease.

"I sensed it was you," Balese said warmly. Victoria joined her fixation on their target within the energized gaseous shroud. "We are back home," Balese murmured.

"This is not my home, and it will never be," Victoria retorted

in a hushed tone. The two rogue sisters stood silent as a group of heavily armed soldiers made their way past them. When they were gone, Victoria turned to her sister and said, "Ready?"

Their plans would go into motion when they gave the go ahead signal to the sisters on Letalis and Necropis.

Balese nodded. "Yes, no time to waste on our part."

As laid out beforehand, she and Victoria would strike in a synchronized fashion with the other sisters on Letalis and Necropis. That moment was rapidly approaching. With little time to spare, they needed to take a designated Synogog transport ship to the Mecropex to complete their mission and utterly decimate the core laboratories.

"Attention passengers. We have arrived at our Necropis destination. Prepare to disembark immediately." The ship-wide announcement repeated twice more while Balese and Victoria made their way with others to the main cargo bays.

The cargo and landing bay doors opened, allowing a rush of cool air to come in, buffeting their bodies momentarily as the pressure equalized. They waited behind the last cluster of other Synogog members and a few of the flight crew near the bottom of the cargo bay ramp.

"Wait for me," a female voice bleated. Balese and Victoria turned their heads to see Avisha Khanon walking briskly in their direction. "Well, are you two ready to go?" Avisha huffed, slightly winded, as

she hurried to their side.

"Go where?" Balese looked inquiringly at Avisha's face, which glowed with exertion.

"To our new labs of course." Avisha proffered a genial smile and caught her breath, then continued. "Don't you want to see where I believe we are going to be working next? You will love all the new equipment." Avisha's wide-eyed demeanor demanded an answer.

"Avisha, we just arrived home and you want us to go straight to work?" Victoria's voice rose, slightly annoyed.

"Well it's not as if you have family waiting for you, right?" she said in a factual matter, seemingly oblivious to any offense she might inflict with her insensitive statement.

That remark aside, the sisters knew that Avisha had genuine affection for them. Their young protégé was aware that although Balese and Victoria had been regenerated by Cymbratar, their reproductive organs were not. But she was oblivious to the fact that Balese and Victoria had put their reproductive organs into a dormant state, believing instead that it had been caused by overexposure to Talthak radiation from the Mantis Alliance destruction of Leviathan-related factories on Gahenna. With grace, they forgave her ignorance.

The commotion of families reuniting with their loved ones near the ramp caught the attention of all three of them.

"Come with me. I don't like to travel alone. What better company than you two?" Avisha said with pleading eyes.

"Sure, why not," Victoria responded with a gentle smile.

Avisha took a step closer to Victoria. "Having a family is great. But the way I see it, our colleagues will outlive their spouses and children, which is a very hard thing to endure. Believe me, it's better to stay as we are," she said, looking over at the other Synogog members and their families. "Besides, we are a family of sorts, aren't we?" Her affection for them was clearly evident.

Balese, with her engaging ways, immediately assuaged any sense of rebuff the young woman might feel. "Yes, I guess you are right. But I still need to finish key adjustments to the Necronadium multiphasic energy inverters to complete my final work cycle on Pratheous. You know I take pride in the details of my work." Her easy smile was contagious.

"Yes, yes, I know that. You can join us when you are finished with your last inspection. Besides, I already have a ship waiting for me in sector five, bay twenty-three, that is cleared for departure!" Avisha looked at Victoria, who shrugged her shoulders in acceptance. "Then it is settled! Follow me." She chirped happily and made haste toward the sector five transportation hub.

"That no doubt must be a benefit of being Gandu Khanon's niece," Balese said loud enough for Victoria to hear. "Let's go, shall we?"

They quickened their pace to catch up to Avisha. They looked at each other, knowing that they were dealing with one of the contingencies that they had discussed before. The question on how to deal with Avisha, whom they had grown to care about, now came to the forefront. From what the young woman had divulged

over the course of spending time with them, she was the only child of Gandu Khanon's youngest brother, Attu Khanon. The special treatment from her uncle was driven by the fact that most Khanon families had between eight to ten children. But the Overseer never had a child as brilliant as Avisha, so he looked after her as she were his own child.

Avisha entered an empty transportation shuttle first, followed by Balese, then Victoria. "Avisha Khanon. Take us to sector five, bay twenty-three," she ordered loudly.

In short order, the shuttle arrived at sector five. Without a word being spoken, they stepped onto the mobility walkway, which would take them to the entrance of highly restricted ship bays. Military hovercraft drones flew along with them and broke off after they stepped off the moving belt. Just a dozen meters away the arched Nazar gate awaited them. As often as they had passed through, the pointed weapons of the military guards still made Balese nervous. The gate covered them with beams of green and red light to further authenticate their identities and clearance as senior Synogog members.

Balese darted a glance at Avisha to her left. *Maybe we can use her ravenous appetite for new discoveries to our advantage.* The thought was not in opposition to her desire to save Avisha from the coming decimation.

"Is it my imagination or is it colder than usual?" Avisha asked, rubbing her gloved hands together for warmth in the wide hallway.

"Bay twenty-three," Balese commented, noticing the white puff of air in front of her face as she spoke.

The top of the door lit up just before they reached it, and the three of them paused in their step. A moment later a holographic image of a middle-aged man wearing Qwravasha vestments appeared directly in front of them. It was the familiar face of Gandu Khanon, Avisha's uncle.

"Greetings Avisha, I see that you are immediately returning to your duties. That is commendable. I myself have just left Necropis and am heading to the Mecropex. When I arrive, I would like to discuss a new project for you to take part in, as a reward for your years of hard work." His hand lifted and he placed it over his heart.

"Thank you, Uncle, I mean my lord," Avisha replied, her voice filled with thinly veiled excitement.

"I know that you will really enjoy this new project," Khanon said with a smile. His face hardened as he turned his attention to Balese and Victoria. "In the very near future, you will take direction from Avisha Khanon. She will have charge over you."

"It will be my honor, Lord Khanon," Balese said. Victoria replied in the same manner.

"Until I arrive, Mullgoth." The image vanished before they could respond in kind.

Avisha turned to Balese and Victoria, looking smug. "What did I tell you? And wait until you see the new lab." She released a giggle of excitement, then stepped up to the large door, activating the various scans before the door slid open.

The thin malleable reflective eye shielding in the hoods of their Synogog cloaks activated, reducing the sun's direct light in the wide-

open ship's bay. The shuttle, created from unique materials from the realms of Creminmorta, was used exclusively for Synogog members to travel through the protective shielding of the nebula cloud. The impressive skyline of the City of Otta was visible on the horizon as they moved around mobile supply racks. It was eerily quiet despite the occasional ship passing by; only the sound of the automated machines high above them broke the silence. In short order, they came to the long range shuttles equipped with specialized shielding and engine drives necessary for travel to and from the mysteriously formed nebula cloud, where the womb of the ungodly children of wrath resided. The trio strode to the bridge. Avisha sat in the main pilot's seat, while Balese and Victoria took their preferred stations to begin departure procedures.

"Sector Five Hub Control, this is Avisha Khanon. I am transmitting my ID and authorization codes." She placed her left hand on the lit portion of the main control panel. "Authenticate." Her loud and clear tone activated an intense burst of bluish light around her palm. The skin of her hand became nearly transparent as the scan penetrated clear to her bone and DNA, while her right hand entered other sets of commands on the panel to her right.

"Authentication of Avisha Khanon accepted," the automated voice said.

Avisha turned to Balese. "Have we received the new shield base frequencies?"

"Yes. I am analyzing them, comparing them against the previous cycles of energy signature fluctuations of the nebula." Balese not only excelled in bio-sciences but also energy sciences. She

understood why having a live person on this station was necessary. Automations did not possess critical thinking, mainly, or decision-making skills for self-preservation.

"Authorization for Synogog shuttle ATG-559-565-293 departure granted."

The dull thud of the docking clamps retracting echoed through the ship's hull. The bay's shielding crackled as the ship passed through, into the horizon where the rays of early dawn pierced between the snow-covered mountain peaks. The serenity and the natural beauty of the continent reminded the sisters of their home, Ramah.

The ship sliced its way through high altitude clouds, then into the sub-zero vacuum of space, and to their destination.

As many times as they had seen the mysterious energized nebula, Balese was still perplexed as to how it shielded the enormous energy contained within. The almost unbelievable power and technology to form such a creation reminded her of the legendary creative works of the thirteen races of the Kelkemeks during the time of perfection, like the Bisgabeths.

"Amazing, isn't it?" Avisha broke the silence with her rather loud observation.

Balese couldn't help smiling at her enthusiasm. "Yes, it is." They gazed into the mesmerizing, vivid bursts of colors flashing between the thick black roiling mass. Two Krauvanok Tartak class battle cruisers became visible in the distance just outside the cloud.

Avisha activated the exterior shielding and closed all the viewports, including the one on the bridge. This was a necessity when traveling through the thick, highly charged nebula cloud. Balese made quick emergency adjustments to the shields to compensate for minute but powerful energy shards that were buffeting the hull.

"These core energy frequencies are vastly different from any previously recorded," Balese shouted over the din.

Avisha turned to face her, cheeks red from the heat and eyes wide. "Do you feel that? Our shields are failing! Fix that or we will be burnt to a crisp shortly!" The panic in her voice was clear. The ship was violently buffeted, jolting her attention back to flying it.

The sweat beading on their foreheads and the smell of heated components emphasized the dangers of traveling to the Mecropex. Their heads jerked back as the ship took a direct hit from a cloud discharge.

"Balese!" Avisha shrieked.

"I almost got it," Balese responded with a heightened sense of urgency. Both of her hands were a blur as she rapidly entered commands and equations.

"I hope so," Victoria chimed in just as another stream of energy slammed into the ship and it rolled over one time, hard.

Various screens erupted in sparks, and wisps of smoke filled the air as the ship managed to right itself. The poisonous and heavy smell of hot metal and other burning components nearly caused Balese to regurgitate her earlier meal. Victoria manually engaged the emergency internal atmospheric filtering system, and in short order

the smoke began to dissipate. The sisters had been trained in their youth in the monastarium to hold their breath for long periods of time, so they did just that as the ship slowly changed the toxic fumes to bad-smelling but inert air.

When Balese and Victoria turned, they saw Avisha's head resting on her chest. They rushed to attend to her. It was apparent by her graying pallor that she had been poisoned by the toxic fumes.

Balese leaned forward, preparing to catch her if she pitched out of her seat. "You don't look good, Avisha." Her voice was filled with genuine concern.

"We are receiving a coded message from one of the battle cruisers asking if we need assistance," Victoria said.

"No," Avisha said at once, shaking her head.

Victoria hesitated, sharing a look with Balese. "Sending a response now that we appreciate their diligence but we require no assistance at this time," Victoria said with quiet concern, as she leaned forward and entered the message.

"I don't feel good at all." Avisha reached into her vestment and retrieved a small container, fumbling for a moment before she opened it. Inside was a small, oblong gel capsule that glittered dark red like a precious gem. She held it up for the sisters to see and popped it into her mouth, swallowing heavily. "The Cymbratar has omni-toxic cleansing properties, if you did not know already." Her voice was hoarse from the irritating fumes. "I have been saving my allotment for an emergency."

The color began to return to her full lips and face. Balese exhaled

in relief at the swift improvement in her condition.

"Good to see you recover so quickly, Avisha." Victoria patted her on the shoulder and, keeping with Leviathan project protocols, returned to her station to send a ship incident report to Synogog headquarters.

After the rare energy frequency oscillation of the nebula cloud finally passed, the ship's shields were slowly deactivated and retracted, allowing them to view the orbiting station near the Mecropex and the dark moon where they would part ways.

"Synogog ship ATG-559-565-293, proceed to docking station eight. Transmitting authorization now," said a female voice.

"Acknowledged," Avisha responded. Her voice was strong now, indicating her complete recovery.

There's my grave. The thought hovered in Balese's mind as she viewed the blighted moon and her destination, known as Pratheous. The sisters had discussed the potential outcomes, including the possibility of their deaths. Balese toyed with how she might react in that scenario, but felt a peace, for the moment anyway. The blue and red terrain adorned with patches of clouds and small bodies of water looked dangerously beautiful at first glance. On her first visit she had not been surprised to hear others refer to it as the black moon.

The inhospitable moon had a complete lack of indigenous life. Even the seas and land were almost void of life, with only sparse vegetation and trees. This, Balese had discovered, was due in part to the large amounts of Cremindraux and other deadly forms of

radiation, which leaked into the main water tables.

For a fleeting moment, Balese again tried to figure out a way to save Avisha from the coming destruction of the Mecropex. But ultimately it would be up to Victoria to decide her fate. That is if she could without risking the success of the mission.

The sounds of the ship docking with the orbital station signaled it was time for Balese's departure.

After logging off her station, she turned toward Victoria and gracefully rose to her feet. "I will see you two later." Her optimistic tone masked the sadness in her eyes, as her spirit knew she would never see her dear friend again on this side of Bayit El.

Avisha's eyes remained fixated on the ship's damage report. "After I meet with my uncle and receive my new assignment, I will contact you, Balese." Her tone was shaded with smugness. It was clear that she was feeling much better, back to her high-minded self-importance.

Victoria nodded and her lips moved, mouthing goodbye before Balese exited the ship.

Through the viewport, Balese observed Avisha and Victoria head toward the Mecropex. *To our success, my dear friend Victoria,* Balese silently prayed as she donned the radioactive protective gear.

She entered the automated service shuttle and placed her hand on the ID scanner near the door, which turned green. A few moments

later, the shuttle began its descent to Pratheous. Balese cleared her mind and rehearsed the timing of executing their plan. She would strike first and then Victoria would make her move. There would be no doubt to Victoria when she had completed her portion of the mission, as it would be visible for hundreds of kilometers.

Yaqal 18

I was birthed into burning dust of misery, placed within the tempestuous fiery furnace of this life. Molded by its cruelty, I am beggarly of hope. I am sickly of little faith and the shattered pieces of my soul's heart cry out for mercy but are swallowed up by the maw of cold darkness. But I gaze at the radiance of HIS GRACE, which breaks the iron gates of my hopelessness. HE covers me under HIS wings and my faith is strengthened. HIS SPIRIT heals the many wounds of my heart.

The shuttle landed just as she finished the Marium Kahnet dirge in her spirit. She adjusted her radiation suit and was pleased to see that there were only a handful of individuals scattered about in the noisy transportation hub. Sensing strongly that no one had noticed her arrival, she briskly walked out of the landing bays and into one of the auxiliary corridors.

Having studied the auxiliary and abandoned maintenance routes over the years, she created a mental image of the small maze of access ways located along the outer sections of the complex in amazing detail. As planned, she entered the scavenger warrens and rarely used corridors, allowing her to avoid internal security monitoring by taking this indirect path to the primary reactor cores. Balese jogged nearly a kilometer through a labyrinth of access ways, dimly lit and unmanned junction stations.

When she stopped to catch her breath in a transition juncture, she was pleased to see a Mobile Personal Transportation Vehicle (MPTV). Motionless, her ears perked up, listening for the slightest hint of approaching personnel. *All clear*, she thought and moved quickly to the vehicle. With fluid motion, Balese removed the main access panel and tossed it on the seat. Just as expediently, she disabled its tracking beacon with a controlled electrical short. She triumphantly hopped atop the MPTV, and shorted out its communication system.

Placing her hands firmly on the power and maneuvering handles, she drove it to a narrow access way. The MPTV just barely fit through. It gradually picked up speed and occasionally sparks erupted as she scraped along the metal walls. *Can security detect the vibrations of MPTVs hitting the walls?* She shook off the speculation. *Must be near the main reactor cores.* Sweat soon broke out on her forehead; the heat was increasing. "I need to hurry before the powers that be mark me missing for duty," she muttered to herself. "Not good." With a gusty puff of air, she blew the sweat from her upper lip.

The MPTV squeezed through the last turn. "There it is; I hope I can open it." She jumped off the seat and trotted to the door, which led outside the main complex. "Here I go," she said with a sigh. In a blink of an eye, she opened the door and slipped inside, closing the door behind her.

The unbearable heat came on strong. She felt as if she was going to melt.

"Abba El, forgive me for my many iniquities," she said humbly.

Then with careful speed, she stepped onto a narrow ledge jutting out of the wall that led to her objective. The thrumming sounds of

the multi-phasic matter fusion core reactors increased in volume as she drew closer to them. Her eyes darted continuously in every direction, in this inhospitable and unfamiliar place, searching for hidden danger. She successfully made the ninety-degree corner, and froze for what seemed an eternity.

For the first time, she beheld the massive scale of the construct that held the Traghedrin Key in the artificial underground domed cavern. Her analytical mind estimated it to be hundreds of kilometers in diameter. "So the rumors are true," she said in quiet horror.

To her left was the bridge to the kingdoms of the Tisrad Dragon. Two tall towers flanked either side of the entrance, guarded by two menacing beasts. Each stood six meters tall with thick short tails. She had read about these in the Eronash, the sorcerers' book of power that was required reading for all Synogog members. She recognized them as Chengudin, the second highest order of Surapharin. They possessed the power to breathe hot plasma out of their mouths and wielded powerful Tisradax swords, forged in the mines of Daugravog. She wondered why there was such a disparity in the physical appearances between the various ranks of Surapharin. Like the mysterious Tisrak, whom she felt were actually lower ranked Surapharin, called Kragudin that wielded mystical powers.

Shaking her head to clear her musings, she looked sharply above the heads of the Chengudin, who were also looking up. They moved to engage a pack of flying monstrosities with menacing yellow and green eyes that were easily visible against the black walls of the dome, diving to attack. Four of the beasts landed just in front of the ominous guards, who immediately lashed out with both swords and streams of fire from their mouths. As the beasts were pushed

back by the force, the three other beasts attacked from overhead, whipping their tails at the Chengudin. The fiery darts hailed down upon them, penetrating the surface of their charcoal skin. The guards roared in anger and pain and flailed their swords at the flying beasts trying to cut them down. With the precision of a military strike, small energized pieces of the swords pierced the wings of the beasts, causing them to fall to the ground. But even wounded, they rose up on their hind legs and lurched to where the guards were engaged with the four other beasts.

The battle was surreal, like a terrifying dream come to life as she stood paralyzed watching the mêlée. Balese neglected the stinging on the edges of her eyes from the salty sweat, mesmerized by the pure ferocity of the seven beasts attacking the two Chengudin. Their armor-covered hides glowed every time they were struck by the Tisradax sword or the intense heat of the fire. The more heavily wounded winged terrors backed off, allowing the others behind them to continue the attack. *These must be some of the beasts they created. They've been trapped here since before Victoria and I refined the final Leviathan process.*

The magnitude of the task ahead of her suddenly threatened to overwhelm her. But just as her panic rose, she sensed a reassuring presence fall upon her. Lightness and peace filled her as a heavy weight was lifted off her. *Thank you so much, Abba El, for your mercy on me,* her heart said.

"Do not delay. Move quickly," said a strong voice.

In that instant, her spirit rose up in her as she girded herself for what lay ahead. Her head darted from side to side to see who

had spoken but she found no one. Overcome with fresh urgency, she broke into a run, pausing briefly to navigate a sharp corner. She ran as hard as she could, grateful that the Chengudin were occupied. As she continued she looked at the looming horizon. "A Necronadium!" She gasped in astonishment. She knew it was a gateway system used by Necrogog forces. She could just make out the bluish traces of a force field of some kind that separated tens of thousands of Necrogog warriors from other life forms, most likely those winged creatures, she guessed.

Not breaking stride, she spotted an entrance to an old chilled water supply channel a few hundred meters ahead that had been used to cool the first sets of reactor cores, and veered toward it. Fear paralyzed her again, and she glanced upward to see with horror the flying beasts that were now swooping toward her. "I'm not going to make it!" she yelled desperately.

Her soul felt the first stab of failure, and the moans of bereavement welled up from within its depths. Tears streaked down her cheeks, but evaporated quickly in the heat. Her lungs bellowed with all the strain of the sprint. Her body began to shiver as the crushing claws of defeat and hopelessness pierced her mind.

With grim determination, she yelled at the top of her lungs, "Look upon your lowly hand maiden. I humbly enter under your protective wings of safety. You are my strong tower of refuge. My soul rejoices in your salvation."

She would not stop her advance until they struck her down. Mid-stride, she darted a glance at the flying beasts only to see that they had stopped near the entrance, hovering and holding their positions.

She was baffled by their actions, and could see the intelligence in their eyes as they looked to each other in confusion. Their attention was not on her but on something near the door she was running toward.

At that very moment, a blinding white light burst appeared just off of the walkway, causing her to squint. She turned her head and peered into the cloud of light. Her spirit instantly recognized the dozen beings within it were Malahtim—divine guardians who serve Abba El. They shined brightly with their swords drawn toward the flying beasts.

"Fear not and take courage, daughter. Finish your race in faith and you will receive your crown of victory over this life." The clarion voice rang loudly and seemed to echo about the cavern.

A short moment later, she supernaturally reached the door as if an invisible force had brought her there. When she touched it, she was instantly transported to the other side. Still basking in the glory of what had just happened to her, she continued with renewed vigor to her target. "Abba El sent Malahtim to assist me. The victor's crown is mine!" Her voice burst out joyfully between large gasping breaths. "He is with me. Nothing can stop me now."

She entered the main reactor power regulator and containment modules emergency access way. "This will be easy," she said with satisfaction, knowing exactly how to overload the main reactor core protective shielding and disable most of the cooling systems. "I will see the Messiah," she stated with a joyful smile beaming on her face.

Chapter Nine

RETRIBUTION

Feeling overwhelmed, Victoria stared at the energy conduit between Pratheous and the Mecropex through a transparent wall as she made her way to her office. Her hands were shaking, she realized, and she was beginning to perspire. She clasped her hands together to keep them from quivering, thankful no one was around.

The occasional whiff of sulfur and the warm atmosphere announced she had arrived at her designated work sector. Aside from the unpleasant smell and heat, she was fortunate that she was in close proximately to her target, the multiphasic energy particle convergence oscillators. Her heart continued to pound hard in her chest as she shored up her courage to proceed. She couldn't do anything about the sweating. As planned, she would disable what seemed to be at first glance some insignificant components, which were actually the weak links in the redundant safety systems. Once disabled, the cascading failures would obliterate the Multiphasic Energy Flux Modulation Matrix (MEFMM), where the power from the kingdoms of the Tisrad Dragon melded with those of this realm. After years of calculations, she estimated the issuing blast radius

would encompass all of the key laboratories. She also surmised that the entire Mecropex complex would be contaminated with Cremindraux radiation, sealing off the enemy's facility for millennia.

She gritted her teeth, thinking about ways of escape. But there was no more time for that, so she forced herself to move.

Her dilemma now of course was to navigate through recently added security. The importance of the Leviathans was reflected in the number of high-ranking Krauvanok Alliance military observers due to arrive in the sector shortly. *Where are the Tisrak?* She wondered. They were often seen coming and going between her sector and the MEFMM that was placed atop a metal plateau. She darted a glance to a garrison of Tisradeen soldiers crossing over to her target, and hissed through her teeth. Not good. *I hope I can avoid them.*

Suddenly, sensing something was watching her, she paused and used her extrasensory abilities to reach out into the invisible. She felt a void with a dark presence at the edge.

It was now or never.

Fleeing her office, she steered away from her work station and headed to a series of eighteen-meter long spans, suspended hundreds of meters above the lower levels. Hesitation crept into her heart as she noticed the transparent, fiery, serpent-like creatures on the bridge she was to cross over. "Nossorads," she breathed.

"Do not fear, Moshiach is with you," said a strong familiar voice. One she had not heard since her childhood. In that moment, the pack of Nossorads was bound by ropes of light, and vanished.

She shook her head and blinked. They were still gone. "Did I see

that, or was that caused by the stress of my mission?" she blurted, feeling mystified by it all. Her eyes darted in every direction, seeking possible danger as she stepped onto the bridge. *Nothing is here. Where are the Tisrak? They must be in the observation chamber to view the awakening of the Leviathans.*

She picked up her pace, then seemed to float down the last few steps before entering the nearest hallway. "Made it this far, just a few hundred meters more." Just then, she caught the metallic clanging footsteps of a military patrol approaching her.

Panic froze her steps. Even as a senior Synogog member, she would be questioned as to why she was there. She would most likely be escorted to the inquisitor's office. That would be the end of the mission and most likely her life, seeing that she carried unauthorized explosive materials with her. She gripped the inert compounds and the catalyst that would explode if she were struck by an energy weapon, and placed them behind her just in case one of the guards decided to shoot first.

In a flash of a moment she realized that the corridor was wide and spacious, allowing large pieces of equipment to move easily from one place to another, but was still empty. She moved along the wall, scanning every conceivable entry. Hearing the clanging steps growing louder, her heartbeat sped up.

"Here you are," she said with relief. The ID panel glowed a deep green and just as she removed her hand, the door slid silently open. The sounds of metal boots in quick step caused her to dart inside the unfamiliar place. Adrenaline flooded her body as she pressed her back against the doorway, breathing hard. She heard the loud

echoes of the guards as they passed, then the noise grew quieter as they moved on. *That was close.*

She momentarily closed her eyes and took the moment to think about her dear friend Balese. A single teardrop ran down her check. "I will see you and my family soon," she said in a weepy tone and was struck with the realization that their plans to join the sisters on the Letalis moon had truly just been fanciful thinking. She somehow needed to send the detailed plans of the Mecropex and the data regarding the Leviathan project back to Ramah, and to the Grand Assembly. But it seemed impossible. *Looks like the Mecropex data will die with us, Balese.*

Victoria sniffed loudly and wiped moisture from her eyes. "No matter, I'm as ready as I will ever be." The words reaffirmed her resolve. "Let's see if there is another way to my target." She walked across the white metal floor to a semi-transparent barrier on the other side, and effortlessly passed through it, only to find that her fortune had turned for the worse as the clear barrier turned into a solid wall of metal behind her.

Without an escape route, she had walked straight into the large control center. "What... so this is the way here?" Victory and adrenaline in equal parts flooded her body.

She had found the hidden access to the sensitive apex were the power modulation and energy stream control stations regulated the amount of energy released into the primary convergence point. From there it was distributed into the five Leviathan birthing and stasis nebulas. She had always been fascinated with the technology. It was very similar to the Hagupex device phenomena, which was

simultaneously present within the five Mantis Alliance galactic capital libraries.

She smiled to herself. It seemed her plans had changed for the better. Now she would seal the Leviathan races within their Necronos nebulas by overloading their main power source.

She retrieved the explosive compounds and rapidly assembled four devices that were more than adequate to decimate everything in the control center and beyond. Loosely placing them in a makeshift sling, she placed the sling around her neck. Cautiously, she crept forward along the one-hundred-and-fifty-meter long row of control stations, strategically placing each device.

"Next," she whispered, then assembled the detonator device hidden in her belt. Noticing a wide window across the room, she sidled over in a crouch. Sliding upright using the wall, she peeked at what was on the other side from the edge of the window. Below, in the distance, was the stream of energy that was directed into the five birthing and stasis chambers that harbored the beasts of destruction.

The words from the last book of the Kodashah wisped through her mind:

Mamlakah 13 ⟨ 7

And behold, I see many mighty and frightful beasts from the depths of the dark abyss, which spew torment out of their mouths and have power in their tails to cause untold destruction. The number of them is two hundred billion and it has been given to them to wage war against the five clusters of stars for their allotted time.

Victoria suddenly felt as though she was not alone and looked swiftly around to determine where the sensation was coming from. But there was nothing. She looked through the window again.

Directly below, at the juncture where the concentrated power discharged into the five Leviathan chambers, were tens of thousands of Kragudin basking within the streams of energy.

She slapped her hand over her mouth to muffle the gasp that had unwittingly escaped in her shock. Unsure of what they were doing, her eyes remained fixed upon them long enough for several of them to look up at her. One grimaced at her, baring its teeth in a predatory challenge, but remained in the dark energy stream. *They are soaking up the dark energy.* She marveled at the supernatural sight. The roiling evil emanating from the hoard below was nearly overwhelming, threatening to freeze her in her tracks.

But she broke through, to expeditiously execute her plan. She held the detonator in her hand up to the window, revealing it to the glaring Kragudin. She closed her eyes as she activated it, but a sudden violent shaking caused her head to jolt against the window. The detonator flew out of her hand, clattering across the floor.

Turning to retrieve the device, Victoria stopped as she saw two Kragudin struggling mightily against a twisting energy vortex that had suddenly appeared. *The multitude of Kragudin have vanished save these two...well one...now none.*

"You did it, Balese! Your mission is a complete success!" she shouted in excitement.

The walls of the control room began to crack from the energy

fluctuations. "Time to finish what you started!" Her voice was filled with resolution. Another series of quakes caused a wave in the floor, sending the detonator farther into the center of the room.

"Victoria," a frantic voice said. "This is Avisha. What is going on and why are you in that room?" Her face was twisted with rage on the screens of the security monitors around the room.

Victoria had forgotten to deactivate the internal scanners and security monitors in her haste. She silently chastised herself for the oversight, then turned to the closest security monitor. "I am sorry, but if you wish to live, you need to leave the Mecropex right now. There is no time to explain. The entire complex will be completely destroyed in just a few short moments." Before Avisha could respond, Victoria turned her back and switched off the monitors in the room.

"Balese. I love you, sister. I will see you and my loved ones very soon!" She cried out, coughing from the poisonous fumes and black smoke coming from the burning control panels, but could not find the detonator. *The fire will cause the explosives to detonate at any moment.*

The thought drifted away and then a soothing, calm sensation washed over her. "Death is near. I am not afraid." Her words were muffled by the wind being vacuumed into the vortex. Amid the cracks and pops of failing systems, she heard the pounding of metal boots headed in her direction. She could only hope the young woman had taken her advice and fled.

Defiantly, she stood with her head held high as a dozen or more Tisradeen soldiers fired upon her. She could feel the heat of energy blasts whizz by her as they missed their mark. Her eyes widened in

amazement; she was not hit by a single shot.

A blaze of blinding white light and percussion lifted her off her feet. As she was leaving consciousness, she caught a glimpse of what looked like large transparent fingers wrapped around her. The shape of them was outlined by the wall of fire that had erupted from her set charges.

Groggily, Victoria awakened with a shriek of fear, her hands flailing in the air. She calmed her breathing, realizing she was alone and somehow safe. A gust of white mist as she exhaled dissipated quickly. The cold air nipping at her nose helped her adjust to the new environment.

She had expected to be standing at the gates of Bayit El, but instead was lying flat on her back staring up at the ceiling of a small military styled tent. She blinked and rubbed her eyes. "This is not a dream. I am alive."

Her mind flooded with details of the trauma she had experienced just moments before, including the blinding white explosions. Then the clear memory came. "Did I see Abba El's divine hand?" She pursed her lips in concentration. She sensed that her body was in perfect health. "No injuries. I was taken from the certainty of death to this strange place. But why? Is Balese also alive somewhere nearby?" she wondered aloud, then sat up and saw the large pile of soft amber cushions she was lying on and inspected the soft garments that draped her body. They were vastly different from the ones that she had been wearing in the Mecropex. *Where are my clothes?*

How did I get here and where am I? Question after question flooded her mind.

Feeling a strange object of some kind against her hip, she rustled around and found that there was a loose pocket in the somewhat loose clothing. Pulling it out, she smiled with genuine joy. It was the data chip disguised as a pendant containing the detailed plans of the Mecropex, the Leviathans, and the Stadageos.

Victoria envisioned Balese's smile and the sound of her laughter, then rolled off the cushions onto the hard floor on her knees, overcome by a wave of grief and unworthiness. Helpless sobs engulfed her entire body and she shuddered with the force of them from head to toe. The warm streams of tears coursed down her neck. "Abba El, why am I alive? My heart is wounded with the arrows of grief. Who can…"

She halted mid-sentence and felt the presence of someone nearby, though she had not heard anyone come in. Hastily wiping her tears, she shot to her feet, turning to face the individual. Judging from his attire he was a mercenary. He remained silent for a moment, waiting for her to regain her poise.

He rubbed his nose with his right hand. "They call me Raduu." He bowed his head slightly with his eyes locked onto hers. Looking over his shoulder, she absently noted that it was dark outside, wherever they were. "I found you sleeping near our unmarked base camp." The scruffy-looking mercenary moved closer, wearing a broad smile. "You have been asleep for many hours."

Her eyebrows rose as she glanced down at her clothing. Before she could speak he laughed.

"Don't worry, I had my associates Em and Tola change you into these more comfortable clothes." He crossed his arms.

"Where am I?" Her wavering voice still held a thread of grief.

"We are on a Letalis moon," Raduu said, looking at her skeptically, as if he didn't believe she did not know where she was.

"Letalis moon!" She gasped with wonder and amazement.

He appeared slightly confused before regaining his aplomb. "You will pardon me, sister, but we did a sampling of your DNA while you were asleep. And yes, we know who you are. Victoria Maja, senior Synogog member, previously known as Vivika Nefrisunni, a rogue element of the Marium Kahnet. You have been missing for a very long time." He said it with a mischievous grin.

"Do you work for the Muak'Xod?" she asked.

"No." The blunt statement did not surprise her somehow. "Jazrene Vallo, your spiritual leader, has hired us to gather you rogues up and return you to Ramah…dead or alive. I would rather it be alive." He smiled grimly in challenge. "So behave yourself if you know what I mean, sister." He placed his hand on his large energy hand pistol for emphasis. "We are waiting to locate the other rogues… I mean sisters. I expect that we will find them soon. After all, we have a bounty to collect. It's just business, you know." He stated it as a matter of fact, and wryly shrugged his shoulders.

His eyes widened with interest and he tilted his head forward inquiringly. "Is it true that you have personally assassinated certain individuals, say Kravjin priests?"

"No I have not," she said adamantly. She was suddenly glad he had not asked about Balese. She did not want to reveal her involvement or her potential whereabouts if she was still alive.

"Well that's a shame, I would've enjoyed to know how you did it." He frowned with disappointment.

They both heard the growl of hunger from her belly.

"Hmm, I will have some food brought to you. Oh, and I want you to be aware, there is no way to escape from this location. You may walk outside if you wish, but don't go too far." He smiled widely once again and then turned and left the door wide open behind him.

A cold breeze entered the tent. She was about to shut the door but was lured out into the peacefulness of the dark night filled with beautiful twinkling stars. She slid a fur lined cloak on that was near the door and stepped out.

With her enhanced eyesight, she was able to make out the shape of the camouflaged military module. She went to the ledge with careful steps, and discovered that she was atop a high plateau. The natural tall tower ensured that there was no easy escape even if she had wanted to. She contemplated informing the mercenary of the locations of her sisters on Letalis and Necropis, but decided not to assist him in their capture.

A small blossom of hope began to bloom in her and she contemplated why she had been saved by divine intervention. *My life's journey, which seemed to be at an end, has been altered for a higher purpose I cannot comprehend just yet.* The thought made her feel secure and unafraid.

She gazed up at Letalis, hoping she would see Nia and Taona soon, then returned to the slightly warmer tent and waited for her meal.

On Ramah, Jazrene remained encouraged from the morning meeting with Petros, the senior Veth'Shar elder, who had given her the sacred items that were used in the slaying and burial of the Mantis' Messiah. The spirit of Moshiach spoke into her spirit just then. *As it is written in the Kodashah, HIS Messiah will be slain but he shall return and rule all creation.*

As it was nearly time for sleep, she donned clothing more appropriate for rest and continued to commune with Moshiach. *Amazing how Abba El works. Both Petros and I were told several times in dreams that Veth'Shar were to retrieve those items and bestow them on the Marium Kahnet... and so they have.* She quietly reveled in seeing prophecy come to pass and felt highly favored to take part in it.

Remembering one last task that needed to be taken care of, she reached into a recessed wall shelving unit and picked up a lone data pad, then headed out to her private balcony for fresh air. A cold breeze swept across the terrace and her long white gown fluttered in the breeze as she gazed up toward Ragoon Two. Breathing deeply, then exhaling, she prayed. *Abba El, I have delivered the sacred items to the ordained jeweler for the creation of five sacred necklaces for the Hadassahs that I will ordain. Since midday, I've had a strong sensation that the time of my departure will come soon. I am not afraid.*

Feeling the lightest touch on her hand holding the data pad that

was propped on the railing, she opened her eyes to see a luminescent Vipusfly gently opening and closing its glowing green wings. *Spring, the time of renewal.* She lifted her hand to the breeze, and watched it flutter down to the flowers below. Remembering her task, she removed a small disc from the ornate wristband given to her by Melah earlier and inserted it into the data pad, which immediately lit up.

Message: In process of loading cargo. Expect
delivery in the next few days.

End message. · · · ·

Jazrene touched the screen and erased the message, removed the disc, then put them both in the deep pocket of her gown. *A few days.* She repeated it in her mind once more, then she recalled a similar message. "No, not again." Her voice taut with grief was filled with a sort of pleading. "Please let this outcome be different from the last time I ordered Lakad two years ago." The sorrow and pain resurfaced as if it had happened just yesterday.

One at a time, she saw the images of the forty deceased wayward sisters who were returned back home in her mind. Their unclaimed bodies were now buried in the unmarked graves of the unknown. One of the pale lifeless forms had strongly reminded her of her daughter Minna Lavine.

"Oh, please!" A sob burst from the depths of her. "Oh please Abba El, don't let it be…" Her voice trailed off. She dropped to her knees on the cold marble floor, and earnestly prayed for mercy on those captured to come home alive.

"Have faith, and do not be afraid." she heard in her spirit.

Somewhat encouraged, she wiped her tears away with her sleeve, then got up off the cold floor, laying all her cares down. *I will prepare as if my daughters will be alive.* Looking once more at the canopy of beautiful stars, she placed her hands palm to palm. "Moshiach is my center, the source of my peace."

MARIUM KAHNET OATH

Every member of the Marium Kahnet sisterhood must take the sacred oath, and those who wish to live their lives accordingly are also encouraged to take the oath.

THE SHABAUH

I pledge my life as a vessel of light as I step through the veil of divine purpose. I am cleansed in purity. My head is adorned with humility. The ways of the Marium Kahnet are my life, my heart and my soul belongs to Abba El, and in HIS messiah is my salvation.

BOOK ANNOUNCEMENTS

<u>Marium Kahnet Book Trilogy</u>

RETRIBUTION Available now

DECIMATION Coming soon

REBIRTH Coming soon

Mantis Force Expanded Universe Presents

<u>**Mantis Force Fiero Series**</u>

FIERO ONE Available now

FIERO TWO Coming soon

FIERO PRIME Coming soon

Made in the USA
Columbia, SC
23 December 2017